LESSONS IN PICTORIAL COMPOSITION

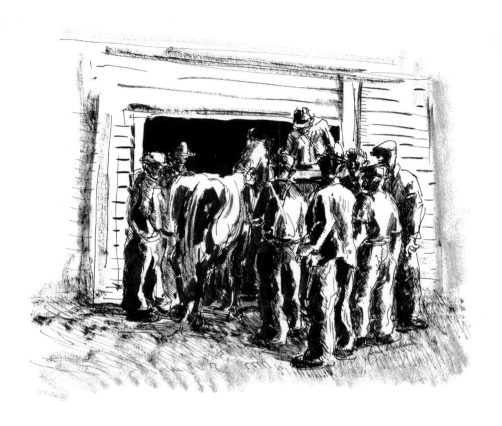

LESSONS IN

DOVER PUBLICATIONS, INC., NEW YORK

Louis Wolchonok

PICTORIAL
COMPOSITION

BY THE AUTHOR OF *Design for Artists and Craftsmen* AND
The Art of Three-Dimensional Design

This Dover edition, first published in 1969, is an
unabridged and unaltered republication of the work
originally published by Harper and Brothers, Pub-
lishers, in 1961 under the title *The Art of Pictorial
Composition*.
This edition is republished by special arrangement
with Harper & Row, Publishers.

Standard Book Number: 486-22181-4
Library of Congress Catalog Card Number: 78-84929

Manufactured in the United States of America
Dover Publications, Inc.
180 Varick Street
New York, N.Y. 10014

To my wife E. H. W.
and to the memory of L. S. and R. Y.

CONTENTS

INTRODUCTION

The white sheet of paper, the stretched canvas stares back at you. It is defiant. It is saying to you, "I dare you. I dare you put a mark on me that will justify spoiling my beautiful white surface." You look hard; you tremble; you break out in a sweat, and you wait, fumbling with the brush in your hand.

"Where shall I begin? What color, what stroke shall I use? What am I trying to say? Only a moment ago I was so sure of myself. I knew exactly what I wanted. I had thought about it, worked it over and over in my mind, but as soon as I picked up my brush and looked at the cold bare surface in front of me, my mind suddenly went blank.

"What is there to fear? What is it that frightens me to the point that I cannot even begin? Am I afraid that I shall not turn out a masterpiece? Am I worried that people will laugh at my work? Do I fear that my new work will not show progress? Am I worried lest my endeavors will reveal my shallowness? Is it the expense that troubles me? Are my inhibitions catching up with me and tying me up in knots?"

Has this happened to you, or are you one of the rare individuals who have never had any doubts, who have never been bothered by the painful process of self-examination? If you are one of these rare creatures, I feel sorry for you. Think of all the trials and tribulations you've missed which in retrospect you would now look upon with a glow of satisfaction. Sure enough, there were problems, trying and painful, and they almost made you give up painting, but you didn't yield. You went on in spite of everything.

I recall an incident that took place in Florence, Italy, more than thirty years ago. I bought what I thought was the most beautiful sketchbook that I had ever seen. The paper was extraordinarily fine, the binding perfect, the whole thing so precious that I was afraid to do any work in that book for fear that I would not do justice to the fine paper and the exquisite workmanship of the thing as a whole. I was old enough at the time to know better, but fear possessed me, and it was some time before I could bring myself

to regard the book as just one more of the many in which I had made hundreds of sketches.

I thought that this was a unique experience until I compared notes with many of my contemporaries. I found that what I thought an uncommon occurrence was shared with slight modification as to the details by almost everyone honest enough to reveal himself.

It was a comfort to me that I was not alone. You may also feel relieved to know that you share with many others—and the list includes many honored names in art—the common experiences of doubt, fear, and apprehension and of overcoming those doubts, fears, and apprehensions.

What does it matter if we make mistakes, if we fumble or hesitate, as long as we persist? Each one of us has his own timetable of learning progress, and it is of little or no use to make comparisons. Each individual must set his own pace and keep at it, and, when doubts and fears arise, as they inevitably do, work all the harder. Work includes thinking about color and composition and all the other art problems that confront the artist. There are some artists who do nothing but think about the work they are going to do and how, when at long last it is done, it will turn out to be their magnum opus. Unfortunately that is not the way things happen. You may be sure that any magnum opus has been preceded by countless lesser efforts.

I. GENERAL CONSIDERATIONS

COMPOSITION

1. *Bare surface.* The bare surface refers to the original size and shape of the paper, canvas, or wall upon which the composition is to be made.

Except in the matter of a fixed mural surface, whose size and shape lie beyond the control of the painter, the size and shape and texture to be worked upon are matters of choice.

The choice is determined by the idea fortified with rough sketches until the definition of the idea becomes fixed. In the process of fixing the idea many shapes may be tried out before a final decision is reached.

There is no fixed rule as to how one proceeds with the initial developments. Many times the painter takes advantage of the standard-size sheets and mounted canvases and stays within those limits, but a canvas can be mounted to any off-standard size and a sheet can easily be cut to the needed size.

Shape, size, and direction play an important role in influencing the painter.

Consider the following shapes:

Shape 1 immediately suggests a composition in which verticality will be important.

Shape 3 stresses the horizontal.

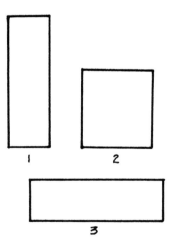

Shape 2 does not command immediate attention for direction because the difference in length between the adjacent horizontal and vertical sides, while great enough to eliminate the square, is not sufficient to establish a pronounced direction dominance. The natural impulse is to emphasize the longer direction but it is important to consider the fact that tensions can be set up by directional opposites. It would not be amiss to stress the horizontal, notwithstanding the longer vertical.

Go back to Shapes 1 and 3. There is nothing that we can do to change the essential vertical and horizontal dominances, respectively. This fact is important because, even before we have put a single line or color on the surface, the four contour lines have played an important role by their impact on the mind of the painter.

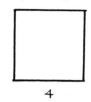

4

Consider Shape 4, the square.

Since the vertical and horizontal sides are the same length, there is no dominance in direction, although some individuals react psychologically more to one than to the other. Aside from this, the diagonal directions play a role in the square which they do not to the same extent in Shapes 1 and 3. In the square it is the corners that are important, and any line that is neither a diagonal nor parallel to a diagonal immediately sets up tension. If the two diagonals of the square are drawn, they negate each other, and the initial interest is shifted to the geometric center of the square.

Any shape that departs from the customary rectangle immediately gives the painter an impulse that tends to influence the composition.

Consider Shape 5.

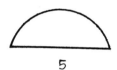

5

In this lunette the arc is a striking contour line. The natural tendency is to incorporate its characteristics into the composition. Not to do so represents a conscious act on the part of the painter to counterbalance the effect of the curved line. We can never wholly eliminate the contour lines or extreme edges, and, except in rare instances, there is no compelling reason for doing so. Using the contour lines to their best advantage in a painting is one of the many problems that a painter must solve as his work gains control and maturity.

2. *Individual shapes.* The contention of the author is that every part of a painting is controlled and that chance and accident play no part in the final statement that appears on paper or canvas. Stories like those about failing eyesight producing color effects leading to revolutionary changes in art or about the drop of paint that creates a new sense of form are romantic, amusing, and entertaining, but they are untrue.

A work of art—if it can be called a work of art—in which chance plays such an important role, is hardly more than a dice game. The freedom displayed in some work stems not from mastery but from desperation, from inadequacy, and from immaturity. Let yourself go! No inhibitions! Fine phrases, but it takes a lot of hard work and study to achieve this state of complete freedom—if it is possible at all.

Every part of the space must be controlled. Let us first deal with the positive shapes. By positive shapes I mean the shapes of the various objects, such as apples, clouds, drapery, figures, etc. In the case of nonobjective compositions, the positive shapes are the areas of principal interest.

When the painter goes out-of-doors to paint and sketch, he sees combinations of shapes and colors which form arrangements that are purely accidental. The chances that any one view will be so perfect as to suit completely the painter's idea are very remote. The sketcher must always select, rearrange, and change some of the shapes to make them satisfy him. Even when the designer sets up his own groups and controls to a much greater extent the forms and relationships of his subject matter, he must make many changes in light and dark placement, shapes, and color; in fact, he must exercise fine judgment in overcoming for his purposes the inadequacies of the natural form.

This is not to say that there may not be any valid reasons for drawings and paintings that represent with great fidelity what the eye sees, but unless the artist invests his work with something that gives a new insight into reality, his function is hardly more than that of a cataloguer.

Study Figure 6 in terms of the positive shapes.

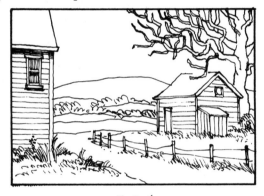

FIG 6

There is a harmonic relationship between the two houses and between the shapes of the field and road in the foreground and the hills in the background. The geometric character of the parts just mentioned serves to integrate the arrangement. Now look at the tree and try to relate it in terms of shape, simplicity, and general harmony to the rest of the composition. Obviously the multitude of branches, which may be a faithful reproduction of the natural form, introduces a change in area relationships that is foreign to the rest of the picture. The painter must express himself in art terms—not in botanical, anatomical, or any other terms—which have a validity of their own distinctly different from pictorial demands.

3. *Composite shapes and combination of composite shapes.* A composite shape represents a group composed of two or more

positive shapes that form a unit whose contour may be readily identified.

Figure 7 shows a composite shape made up of several different individual parts. Taken as a whole, the contour is essentially elliptical, 7A.

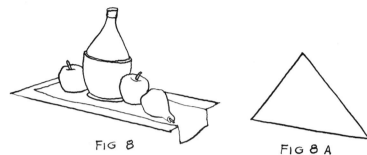

FIG 7

FIG 7-A

FIG 8

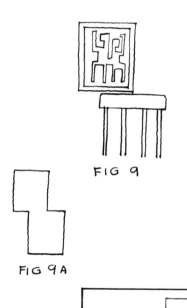

FIG 8 A

Figure 8 shows a composite shape whose contour is essentially triangular, 8A.

Figure 9 shows a combination of two angular parts. The contour of the composite is an irregular shape, somewhat like Figure 9A.

Figure 10. Let us now place our three composite contours within a fixed space. (Repeat any or all of them as deemed suitable.)

Starting as we did with the simplest equivalent of the form (that is, with the plane contour), the arrangements marked A, B, C, and D show clearly each of the composites. However, when as in the arrangements marked A1, B1, C1, and D1, each composite includes its detail, the individual composites lose some of their clarity. In fact, putting the composites together complicates the arrangements in that it creates new combinations.

FIG 9

FIG 9 A

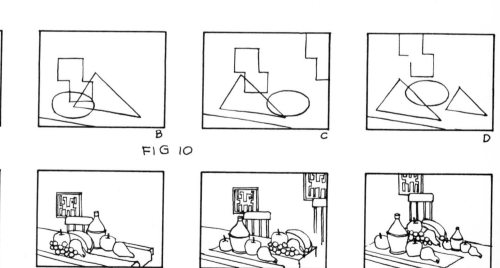

FIG 10

The Art of Pictorial Composition

In Figure 11 some of the new combinations are shown.

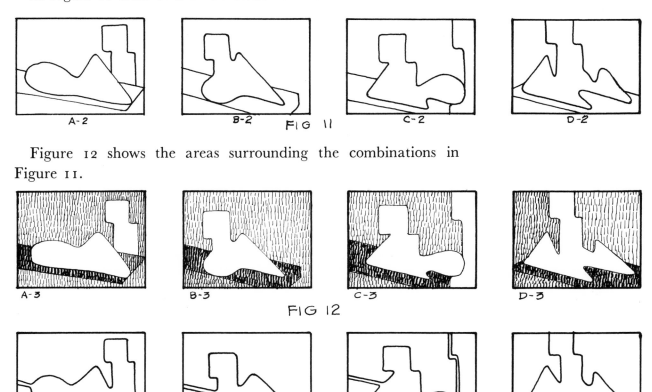

Figure 12 shows the areas surrounding the combinations in Figure 11.

Beginning with Figure 7, we have evolved a set of compositions in which our chief interest is centered on contours, the contour being one of the vital elements in the structural design of a drawing or a painting. We see that each of the significant areas, when considered alone, represents a single phase of the composition problem, and that when these areas are combined, new areas come into being that were previously nonexistent. Furthermore, as the positive areas are modified and altered by the addition of similar and different areas, the so-called background, or "leftover" spaces also are changed. One of the important problems in creating a composition is the control of *all* of the areas.

4. *Movement by disposition of planes of each group.* Each subdivision in a composition must be interesting for its own sake as well as related in some way, or ways, to the whole. Part of this interest comes from the suggestion of form.

When we speak of form, we mean geometric shapes and figures, both plane and solid. Some of the units in a design may suggest

angularity, roundness, or a union of both. Transition from one plane to another, from one surface to another, may be smooth or interrupted. Whatever the character of the picture, it is expressed by means of lines, dots, and areas, all of which have geometric space equivalents, regardless of the type of painting, whether it be realism, expressionism, abstraction, or non-objective. The fact remains that the marks placed on a surface, whether in black and white or in color, do not remain on that surface in their effect on the observer. There is no such thing, strictly speaking, as a completely flat effect. Even if a uniform color is applied to a surface, that part of the surface closest to the contour or frame will not appear to lie in the same plane as the innermost part.

The manner by which the illusion of depth is created helps to establish one very important phase of pictorial quality.

Consider Figure 13.

 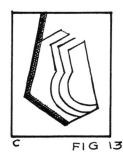 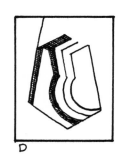 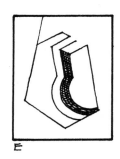

FIG 13

Each of the five examples of Figure 13 has the same linear combination. In Variation A all the lines have the same weight, but the part composed of the three parallel lines seems to advance. In the other variations different areas advance depending upon where the emphasis is.

FIG 14

Consider Figure 14.

In Figure 14 depth perception is achieved in various ways. In Variation A there are three different positions for the eye.

In Variations B, C, and D the position of the eye is fixed, but in Variation B the various planes of the road and the building are not parallel to each other. In Variation C a sense of depth is achieved by the change in angle of each plane from the picture plane. (Only Plane 1 is parallel to the picture plane.)

In Variation D the three vertical faces are parallel to the picture plane. The illusion of depth is created, in part, by partially hiding two of the three planes. In this case change in size does not affect our sense of depth.

In Variation D perspective plays very little part in the effect of recession.

When a composition is created in which the various parts are treated as if they were partially or wholly transparent, neither perspective nor the physical fact that one and only one object may occupy a particular space at a particular time plays a part in the creation of depth. The feeling of going into the picture must come from change of value and color.

Of course, value and color play a most important role in every painting, regardless of any other device that may be used. Ordinarily the least important parts of the composition and those farthest from the observer in terms of ordinary perspective are treated with the least amount of contrast in value and chroma.

However, when areas normally of secondary importance are treated with striking contrast and brilliant color, tensions are set up. The expected recession in depth is interrupted by the unexpected chromatic brilliance and value contrasts.

5. *Movement by controlled flow of line (independent of color).* Movement in depth is always present even though it may be barely perceptible.

This type of movement is essentially three-dimensional in character. Coupled with this is the movement that remains on the plane of the working surface. This type of motion, which we may call "plane motion," may be vertical, diagonal, horizontal, curved, or any combination of any two or all. Just as depth movement is ever present, plane movement is also an integral part of every composition. The degree to which the motion is controlled and the extent to which the motion expresses the intentions of the painter help establish for the painter a critical basis for his judgment of his work.

In Figure 15 each example shows how the plane motion is controlled.

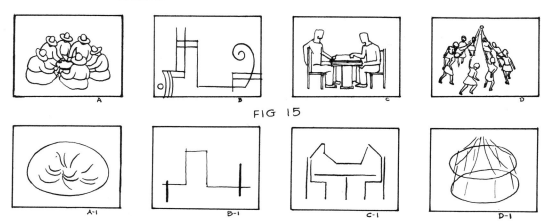

FIG 15

One reason why preliminary sketches for a painting are important is that they enable the artist to examine his ideas in graphic form and to make changes when necessary. The sketches are generally started in the manner illustrated in Figure 15, A1, B1, C1, and D1; then they are elaborated as shown in Figure 15, A, B, C, and D. In each of these stages, changes can be readily introduced until the idea is satisfactorily fixed both on paper and in the artist's mind. If this is not done, indecision rears its ugly head and the struggle to achieve a satisfying work is made very much more difficult.

6. *Movement by color and value contrasts*. Value contrasts refer to the light and dark equivalents of color. When a work is produced in black and white, the whole range of values used are not necessarily expressive of color. This is particularly true in nonobjective works. If a painting suggests recognizable objects, color association becomes automatic, because we live in a world of color. The value aspect loses some of its force, since we tend to equate value and color. However, when the painting or drawing in black and white does not suggest realistic color equivalents, its values are independent of color considerations and thus take on more importance. It must be remembered that if a picture indicates a mood, the mood often has a color equivalent. If the mood expressed is a light, joyous, gay, happy one, the color will be bright and high in key and predominantly warm. If the mood is dark, brooding, sad, contemplative, the color will generally run to grays and be low in key and predominantly cold.

Consider Figure 16.

In Variation A the eye travels from left to right. In Variation B

all of the lines are parallel; therefore, convergence plays no part in suggesting motion. The eye is attracted to the upper right and travels diagonally down to the left and then up diagonally to the right and then back to the starting point.

In Variation C the eye travels along the diagonal from upper left downward to the right, then along a horizontal to the left, and diagonally up to the right.

In Variation D the eye starts at the dark triangle and travels diagonally along the accentuated lines.

The four compositions are essentially purely geometric in nature and can therefore be studied without any reference to color.

 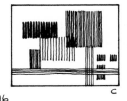

A B C D

FIG 16

Color has a powerful influence on the effect of motion, principally in terms of advancement and recession. It is not necessary to have line as such in a color composition. The dynamic effect of motion, both plane and depth, will depend almost entirely upon the contrasts in value and chroma that are set up. Remember that when one color is applied next to another, distinction between the two colors brings into being a line, or the appearance or suggestion of a line. This line plays an unimportant role in the total composition. The degree of importance that the painter gives to line and color is of his own choosing and depends upon what he says and how he says it.

7. *The illusion of depth—perspective.* Color and line, as used by the painter, exert powerful stimuli on the beholder. The sense of plane and depth motion they generate can be a very exciting experience.

Perspective is one of the devices used by the artist to heighten the sense of motion. Unfortunately the term "perspective" has a very limited meaning for most artists, because they neither understand its fundamental nature nor are they aware of its widespread use dating back to the cavemen of France and Spain. This is not to say that the laws of perspective that are based on that branch of graphic mathematics called "descriptive geometry" were understood by the ancients, but they did have an intuitive feeling for some

aspects of the subject which seems to be lacking in many present-day painters.

First of all, perspective has nothing to do with the physical act of seeing. The normal human eye sees something. That is one thing, and it is independent of the act of drawing. Within certain limits perspective and seeing dovetail, but beyond those limits perspective and seeing part company. For instance, the normal human eye does not enlarge the objects it sees. The normal human eye does not see upside down. As objects of equal length recede, they appear smaller to the normal human eye. These facts are not necessarily true of perspective. In other words, in perspective there is more than meets the eye, but many contemporary painters are unaware of this. I recommend that the subject of perspective be looked into by all painters. It is, among other things, an invaluable aid in drawing and composition, and a sound understanding of its basic principles will enable the artist to work with greater freedom.

Much of Chinese art displays a freedom of self-expression based on the application of the laws of perspective. The Chinese simply eliminated the vanishing point. It is important to remember that before they could eliminate the vanishing point, they had to be aware of it.

Every composition expresses some degree of tension. This element adds a dynamic quality, which gives added life to a picture.

I have divided tension into six types of opposition. Each of the first five divisions is illustrated by three examples. Unfortunately illustrations for "Opposition of color" had to be excluded.

It must be understood that most paintings are not limited to one type of tension. Generally speaking, the greater the number of forces working in opposition in a pictorial composition, the greater will be its dynamic quality.

8. *Tensions—forces working in opposition.*

A. Opposition of weights.
B. Opposition of direction.*
C. Opposition of shapes.
D. Opposition of values.
E. Opposition of moods.
F. Opposition of color.

* "Opposition of direction" refers not only to linear direction but to changes in advancing and receding areas, shown in D and E.

The Art of Pictorial Composition

A

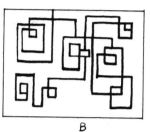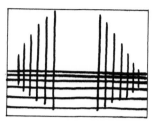

B

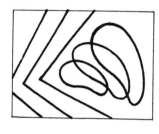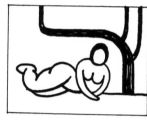

C

D

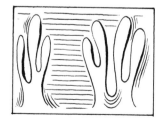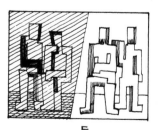

E

II. PICTORIAL COMPOSITION

PICTORIAL COMPOSITION

Skeletal compositions, showing diversity of arrangement

PLATE 1

In Row A the starting line is oblique.
In Row B the starting line is oblique.
In Row C the starting line is vertical.
In Row D the starting line is horizontal.
Each of the starting lines represents a dominant direction.
The two oblique lines suggest greater motion, agitation, stress.
The vertical line is associated with erectness, rigidity, firmness.
The horizontal line induces a sense of calm, equilibrium, stability.
In general:

1. The arrangements in which all of the lines are oblique create an effect of greater activity.
2. The arrangements in which all of the lines are vertical or horizontal express the least amount of activity.
3. The arrangements showing combinations of oblique-vertical and oblique-horizontal lines express varying degrees of activity.

When we draw one straight line within a limited area, such as a rectangle, we are concerned with four things:

1. Length of the line.
2. Direction of the line.
3. Position of the line.
4. Division of rectangular space by the straight line. (This is closely related to 3.)

When we add a second line, we complicate the problem of composition because we must take into account not only the position of the second line in the rectangle but also the relationship between the two lines and the resultant changes in the subdivision of the rectangle.

Note:

1. How the varying combinations of the two lines change the space relations within the rectangle.
2. How the area of chief interest changes.
3. Tensions set up by the increase in the number of areas that vie for attention.

As we increase the number of straight lines, the problem of control becomes increasingly difficult. The composition is not necessarily better or worse for the number of areas into which it is divided, but it is evident from the simple illustration using two straight lines that control is of prime importance.

In this plate, as in Plates 2, 3, and 4, the skeletal structure reveals principally the illusion of motion laterally and in the plane. Motion in depth, which helps create a three-dimensional space sense, is hinted at in some of the examples but is treated in greater detail in Plates 46 and 47.

The lines used give us a preliminary method for crystallizing our ideas. They are shorthand devices and are intended only as such. When in the course of experimenting, a satisfactory arrangement is evolved, it is advisable to stop and try to elaborate it into a more meaningful composition by adding color or values and by expanding the lines into areas.

In Plate 1, Row A is composed of 16 variations, based upon the development of a line slanting upward to the right. Note that the same length, the same direction, and the same position are maintained in each composition. In Rows B, C, and D the basic lines retain the same length, direction, and position.

The process of composition begins with the basic line. As soon as it is drawn in the rectangular space, a device is graphically used to change the character of the rectangular space. The many combinations of lines used for further development may be classified as follows:

1. Parallel lines, not necessarily the same length.
2. Straight lines of varying lengths and directions.
3. Open and closed curves.

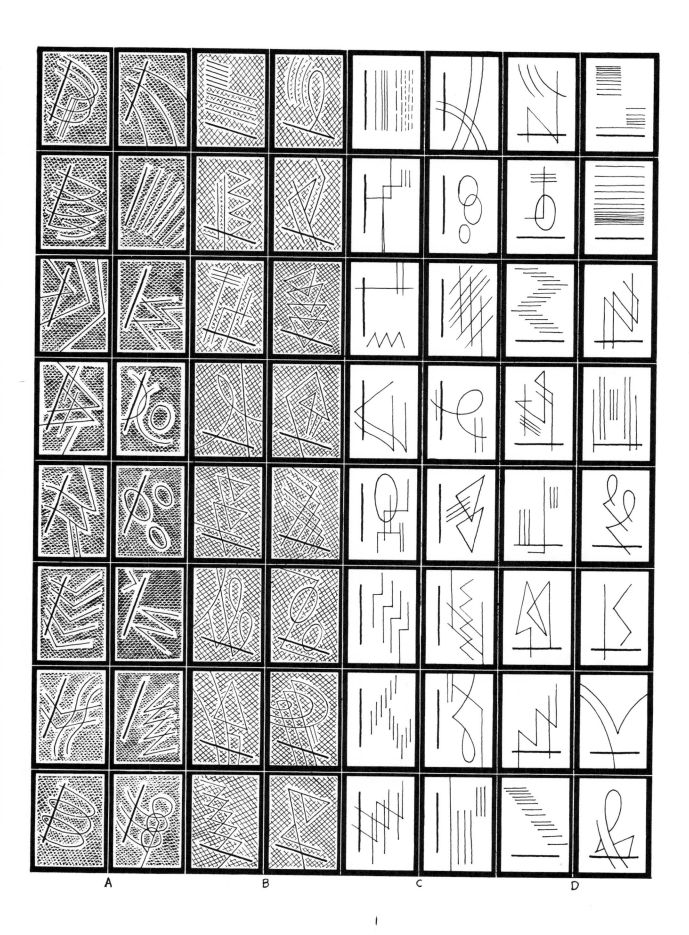

A B C D

Row A. The third design from the bottom on the left has been enlarged and elaborated by introducing variation in the area contours. The essential directions and positions remain the same.

Row B. The second design from the bottom on the right has been transformed.

Row C. The second design from the top on the left has been elaborated.

Row D. The third design from the bottom on the right has been used for further development.

Basic to all composition:

1. Control of the areas, involving position, size, and shape.
2. Concentration of varying degrees of interest, with the greatest attention on the area of chief interest.
3. Sense of motion generated.
4. Tensions created to give a dynamic quality to the design.
5. The mood, which helps express the artist's feeling for his subject matter.

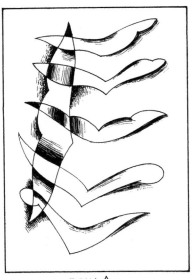

ROW A

ROW B

ROW C

ROW D

PLATES 2, 3, and 4

These three plates, showing 54 compositions in skeletal form, offer a number of basic layout arrangements. The different schematics may be grouped as follows:

1. Area of chief interest centrally located, with balanced subdominants on right and left.

 Examples: Plate 2—F

 Plate 3—D, F, L, and J

 Plate 4—V

2. Composition divided into two large divisions with the area of chief interest in one of them.

 Examples: Plate 2—B, C, L, M, and N

 Plate 3—C and H

 Plate 4—H

3. Tension produced by different sets of converging lines with the area of chief interest concentrated in one of the sets.

 Examples: Plate 2—D, E, and G

 Plate 3—none

 Plate 4—F, G, M, and P

4. Focal area produced by convergence of set of lines.

 Examples: Plate 2—J

 Plate 3—O

 Plate 4—none

5. Radial arrangement with focal area located at the intersection or apparent intersection of converging lines.

 Examples: Plate 2—H and I

 Plate 3—G

 Plate 4—Q

6. Rhythmic flow producing sense of continuity and overall identity of parts.

 Examples: Plate 2—K

 Plate 3—J

 Plate 4—A, C, D, and E

This type of composition generally involves a considerable amount of repetition.

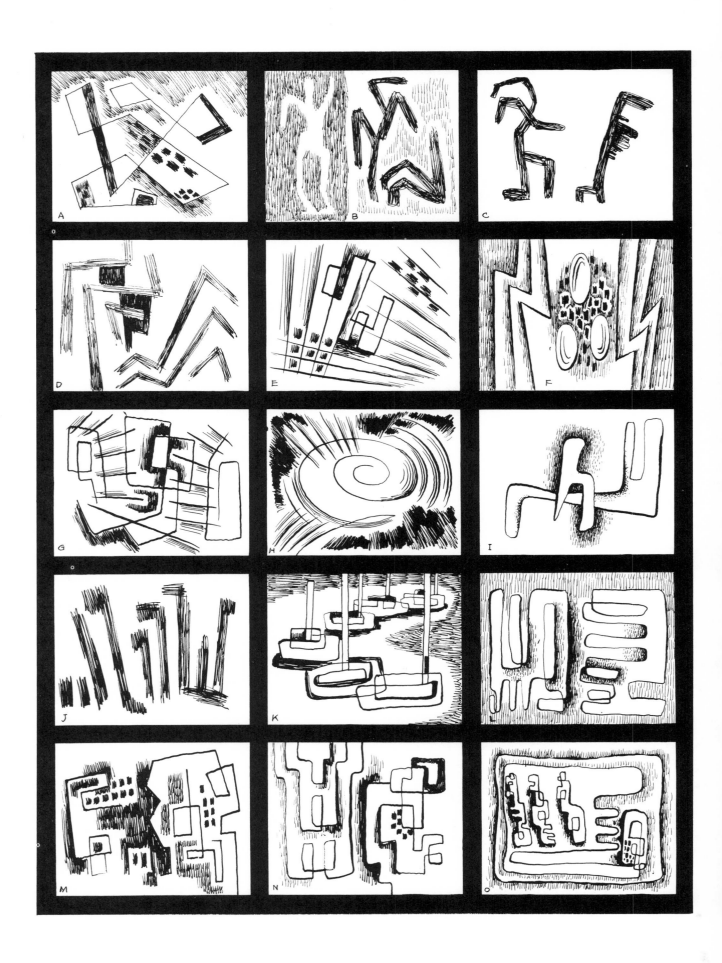

The Art of Pictorial Composition

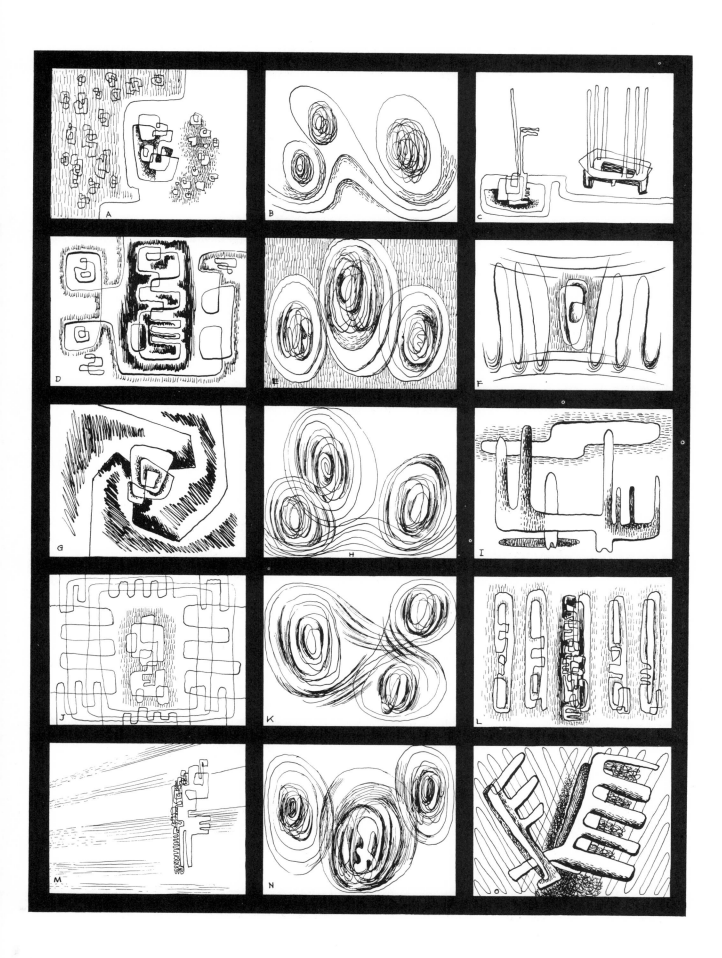

7. Intersection of dominant and subdominant areas.

 Examples: Plate 2—I

 Plate 3—I

 Plate 4—N

8. Variations in the placement and emphasis of a three-unit composition.

 Examples: Plate 2—none

 Plate 3—A, B, E, H, K, and N

 Plate 4—B and V

9. Variations in the placement and emphasis of a two-unit composition (other than under 2).

 Examples: Plate 2—none

 Plate 3—none

 Plate 4—K, O, and T

10. Variations in the multi-unit composition.

 Examples: Plate 2—O

 Plate 3—none

 Plate 4—L, R, U, and W

You will find that many of the arrangements in Plates 2, 3, and 4 may easily fit into two or more of the categories listed. For instance, every composition expresses tension to a lesser or greater extent. Every composition sets up rhythms of one kind or another which may be boldly expressed or hardly discernible, but they are present. Remember that if you put one line on a sheet of paper, rhythm is introduced if the line is parallel to an edge of the paper. If the line is oblique, tension is immediately produced. In most compositions, intersections of lines and areas, if not an actuality, are implied. The real or implied points and areas of intersection set up focal areas of lesser and greater importance.

We may gather from this that in reality there is no such thing as a simple composition. What very often appears to be a simple arrangement may contain combinations of tone, color, line, and area which are so subtle that the casual onlooker misses them.

The student of composition and color is urged to experiment as often as time permits with small sketchy designs as illustrated. To get meaningful variations is not quite as easy as may appear at first glance. The drawings in Plates 2, 3, and 4 are not doodles.

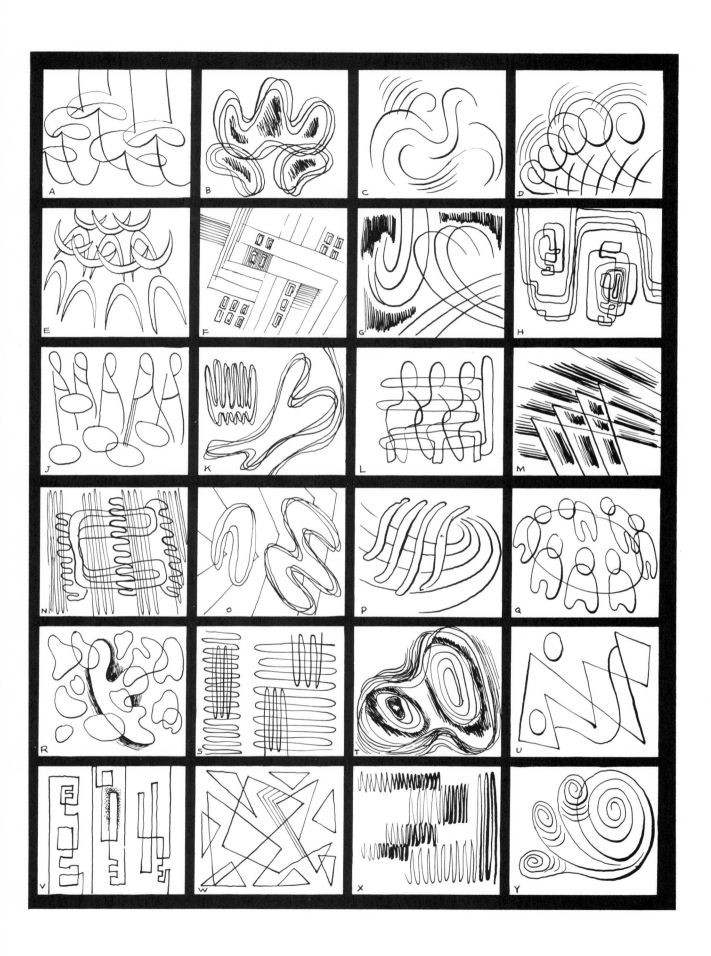

PLATE 5

The power of line is shown in this series of compositions.

Examine each one separately. Each has a character all its own and induces various reactions in the onlooker, depending on the extent to which he relates what he sees in the picture to his own experience.

When two of the compositions are viewed simultaneously, the contrasts between them produce added interest in each one and aid in giving us a greater awareness of the power of line.

A painting may be made with broad brushstrokes to create an effect completely different from a linear rendition, but part of the effectiveness of any picture will depend upon a sense of line, induced by the contrasts of value, color, and direction.

The three bottom compositions are composed of sloping lines, in contrast to those in the rest of the plate. In those designs using horizontal and/or vertical lines, diagonal motion is subtle and indirect. In the case of the arrangements using slanting lines, the inclined motion is forceful and direct.

The Art of Pictorial Composition

PLATE 6

The 15 skeletal compositions shown in this plate represent different moods and different reactions to source material. Some of them are pure invention. I use the term "pure invention" to indicate that I cannot trace the source from which the design is derived. Each of the arrangements is an invention, but it is obvious that Figure H is based on an irregular pentagon. Figure K is based on studies of the human figure, although this fact may not be as obvious to you as it is to me.

Do not be misled by the apparent simplicity of the simplified skeletal figures in the several plates devoted to them. I admit that it is easy to copy them, but it is quite another matter to invent your own.

I cannot stress too emphatically the importance of the constant use of pencil or pen, not only in sketching things you see or remember but in putting them down on paper within a fixed space, creating some semblance of order. The little compositions thus produced become valuable source material for further development into finished works.

Since pictorial composition involves creating illusions in depth, it becomes important to study the skeletal designs in terms of depth, or advancement and recession of various picture areas.

Consider Figure M. At first glance we get a linear sense of motion (up and down, lateral and diagonal). Now look steadily at Figure M. Study it and choose one of the areas as the one that is closest to you, the observer. As soon as you do this, all of the other areas recede, and the effect is motion in depth, or plane motion. By the correct use both of values in black and white and color, we can control plane motion.

PLATE 7 Developments from skeletal compositions.

Figure A might be called "A Theme and Variations." The theme is a triangle. Variations in size, position, intersection, and value help to build a complex arrangement.

The skeletal Figure N in Plate 6 forms the basis for the complex design (A) in this plate. While the essential geometric character of the skeletal figure has been retained, the development into an integrated complete picture necessitated the introduction of additional figures. The movement in the Figure A of Plate 7 is controlled, with the chief emphasis directed toward the center of the total area.

At no time during the process of working out the complete design from the original skeletal figure did I attempt to inject any thought other than that of the abstract, angular, straight-line source. I must confess, however, that as I study this composition long after its completion, I am impressed by the suggestion of moving human figures. I wonder what your reaction is?

In Figure B the general effect is that of a piece of sculpture in low relief. The original skeletal Figure K of Plate 6 was based on figure studies that I had made.

Note that the composition in Figure B is divided into two large parts, with the chief interest left of center.

If Figures A and B were translated into color compositions, many more variations in light and dark contrasts can be made. The range of effects is greatly increased. Full orchestration is possible only with color.

I suggest that as you study the many compositions in this book, you try to think of each one in terms of color. This is a useful mental exercise and helps to project the imagination. It is not necessary to give each area a distinctive color, but to visualize a general color scheme.

When you are actually painting, you must be definite about each area, large or small.

A

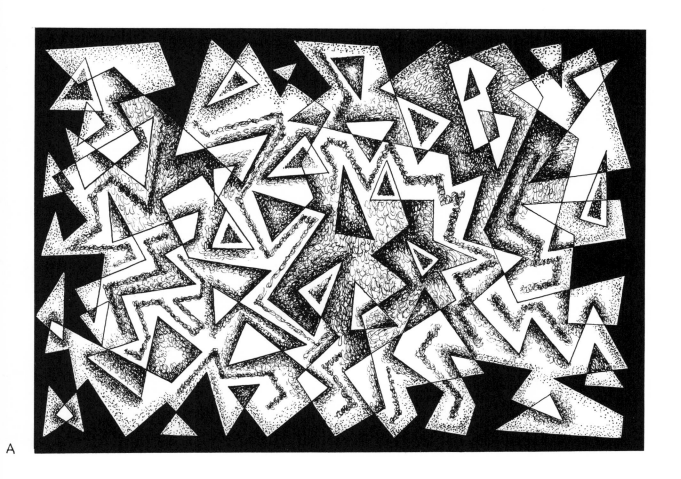

B

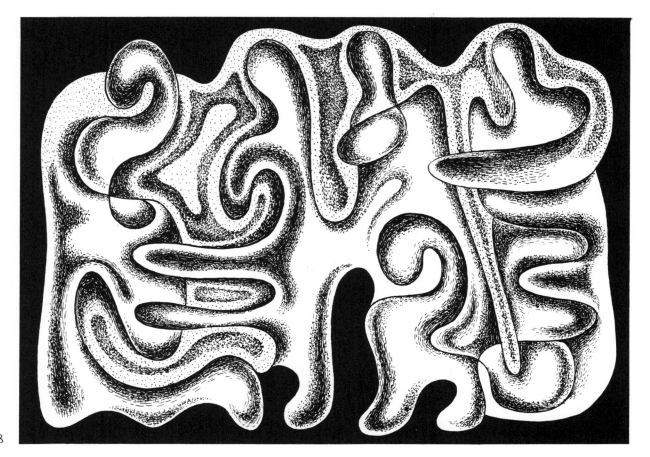

Pictorial Composition

PLATE 8

The skeletal Figures I and G of Plate 6 form the bases for the abstract compositions of this plate. Both are undoubtedly reflections of my interest in the fantastic combinations of geometric forms that I see in New York City. I have made many studies of buildings and street scenes, and I keep storing in my mind the almost unbelievable arrangements that present themselves to me as I wander about the city. I have no doubt that my active interest in some phases of mathematics has added to my awareness of the multiplicity of geometric forms around me. At any rate, even in our simplest line drawings there is evidence of our interest in nature and man-made things. Every drawing and every painting we make is in part a self-portrait.

In Figure C the development of the skeletal drawing emphasizes various space groupings dominated by vertical and oblique lines. Each of the groupings suggests volumes, which might conceivably be derived from buildings. Combinations of vertical and oblique lines create an interesting rhythmic pattern. They create an angularity that imparts sharpness to the design.

In Figure D the basic pattern is the rectangle and some of its variants. The horizontal and vertical lines used throughout help to give the composition a feeling of repose. If you compare Figures C and D, you will see how much more action is suggested in Figure C. Figure D is a further example of a composition made up of two dominants, each having many subdivisions. In this particular arrangement the area of chief interest is centrally located, joining the two dominants.

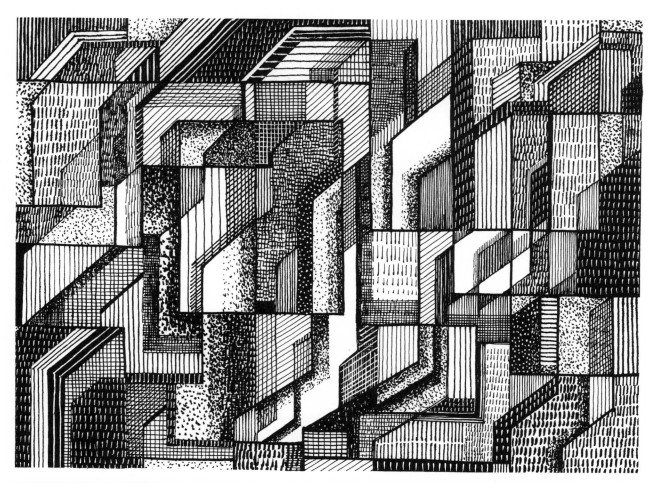

c

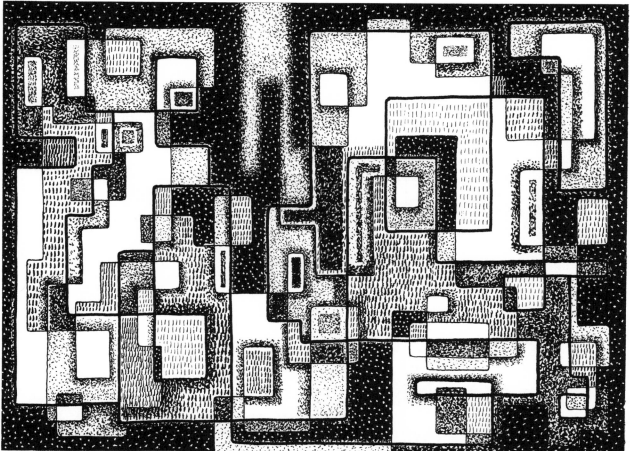

D

Pictorial Composition

33

PLATE 9

Figures M and O of Plate 6 are the skeletal bases for the abstract compositions of this plate.

In Figure E the rhythmic order created by the change in size and position of the triangles, augmented by the converging lines, gives a sense of movement to the design as a whole. This sense of movement, which is essentially lateral, is supplemented by movement in depth, which is the result of the added light and dark values. The general plan of this composition may be called a modified two-dominant design. The modification is derived from the way in which each dominant imposes itself upon the other. It is essentially a theme: the triangle and variations.

In Figure F the composition employs a dominant theme which contains the area of chief interest; a subdominant theme which is closely allied to the dominant, because the curved and straight lines give each theme a somewhat similar character; and a third theme, checkered in effect. The checkered effect is carried out in different degrees in the first and third themes.

This interpretation of the skeletal composition of Figure O of Plate 6 is quite startling when compared with the original, Figure F of Plate 9. I am quite sure I would get an entirely different result if I were to attempt another development of this skeletal composition. The wide range of different results would show how it is possible to react in more than one way to the same stimulus. The subject matter remains the same. It is we who change.

E

F

Pictorial Composition 35

PLATE 10

The four compositions are developments of skeletal outlines A, C, B, and H of Plate 6.

At this stage in our study of composition, we can see that many pictures can be evolved, each one showing a different combination of values or a different distribution of the same values. Further changes can be made by shifting the area of chief interest. Color is another powerful instrument that offers endless combinations. We can never exhaust all the possible variations.

The four arrangements in this plate are abstract and essentially geometric in feeling. Figure I shows groupings of intersecting lines. Figures G, J, and K are intersecting areas. Geometry concerns itself neither with black and white values nor with color. Therefore, when we speak of geometric compositions, we are referring to the combinations of lines and areas alone. The lines need not be straight.

Figure I emphasizes groups of lines and areas in tension. The pronounced changes in direction and black and white contrasts produce dynamic feelings of movement, both linear and in depth. The statement in this design, as compared with the others in this plate, is direct, forceful, almost crude in its expression. It has a feeling of rawness which further differentiates it from the others.

The Art of Pictorial Composition

J

K

G

I

PLATE 11

In this group of five abstract compositions, the basic skeletal figures used from Plate 6 are D, E, J, F, and L. Basic lines and areas are curved in all examples. In Figure L opposition plays a leading role, with emphasis directed to the black areas. Of the five pictures in this plate, Figure L is the simplest in that it has the fewest values and the total space of the design is broken up into the fewest areas.

Figures M and P are somewhat related because the same device of intersecting convergent curved lines is used to help break up the space.

Figures O and R use intersections of closed curved areas. Changes in the geometric character of the closed areas and in the amount of intersection and value contrast aid in giving each picture its individual quality.

The elliptical curve, which has gained prominence since the first man-made satellite was thrust into space, is used extensively in all of the variations. In Figure O the arcs of the composite curves may be regarded as elliptical.

The greatest tension is expressed in Figure R. This is because the area of chief interest is not as striking and there is a more equal distribution of dominant areas, each attracting attention.

The Art of Pictorial Composition

PLATE 12 Dominance of direction; dominance of light and dark contrast.

In each of the twelve compositions oblique direction is the dominant motion. The black and white values add a feeling of depth and help control the movement of the eye. As long as the oblique movement remains dominant, a sense of restlessness pervades each picture. The power of line to express movement and feeling is shown to great advantage here.

Examine the individual areas in each design in relation to one another and you will find that there is considerable variation in the areas, due to changes in shape, direction, and value. The internal structure of each picture takes hold of our interest after we have first become impressed by the dominant oblique movement.

The balance achieved in each composition by the just relationships of the internal parts is offset by diagonal motion. The conflict thus created adds tension to each variation. In some of the illustrations there are sharp sudden changes of direction, causing an increase in tension.

If these twelve compositions were to be rendered in color, the artist would have to decide whether to maintain the feeling of restlessness or to counteract it by a feeling of repose. If he wished to emphasize the former, he would use startling color contrast, while very little contrast would be employed to show the latter.

The Art of Pictorial Composition

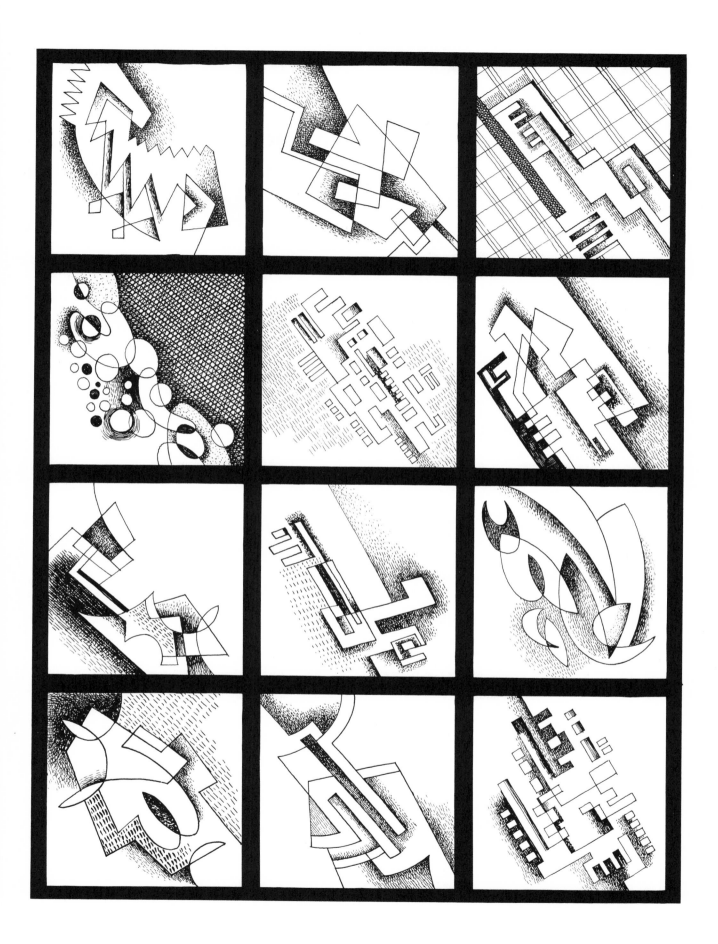

PLATE 13 Dominance of direction; vertical and horizontal (dominant rectangles and variants); effect of enlargement.

The same source material lends itself to varying interpretations, depending upon the way the material impresses itself upon the artist. It takes time for a painter to become sufficiently well acquainted with his subject to do full justice to it. That is why working out-of-doors does not often lead to the most satisfactory results. There is no time for introspection, no time for dreaming. Bear in mind that the vast majority of great art has been produced in the studio, not out-of-doors. This does not mean that painting and drawing on the spot is not of importance. I have urged it and shall continue to do so. The fact remains, however, that our best work is done after we have had a chance to think about our material, digest it, and make it an integral part of our thinking and feeling.

As we change, our reactions to the source material change. In Plates 13, 14, 15, and 16 we have a number of examples of the results of extended periods of observation, study, drawing, and painting, on the spot, of New York City architecture. Elsewhere, I have shown realistic aspects of buildings and street scenes, and these ventures into realism have helped add to my absorption in source material.

The four Plates 13, 14, 15, and 16 deal with variations of my constant wonderment at what I call the "geometry of New York."

In each of the four plates, look for:

1. Dominant areas.
2. Emphasis within dominant areas.
3. Directed movement of eye.
4. Balance of subdominant areas.
5. Key of design in relation to light and dark values.

Pictorial Composition

43

FIG-A

The seven figures on the right are a breakdown of all of the varying tonal areas that compose Figure A, above:

Figure 1 shows white areas
Figure 2 shows black areas
Figure 3, 4, 5, 6, and 7 show gray areas

The Art of Pictorial Composition

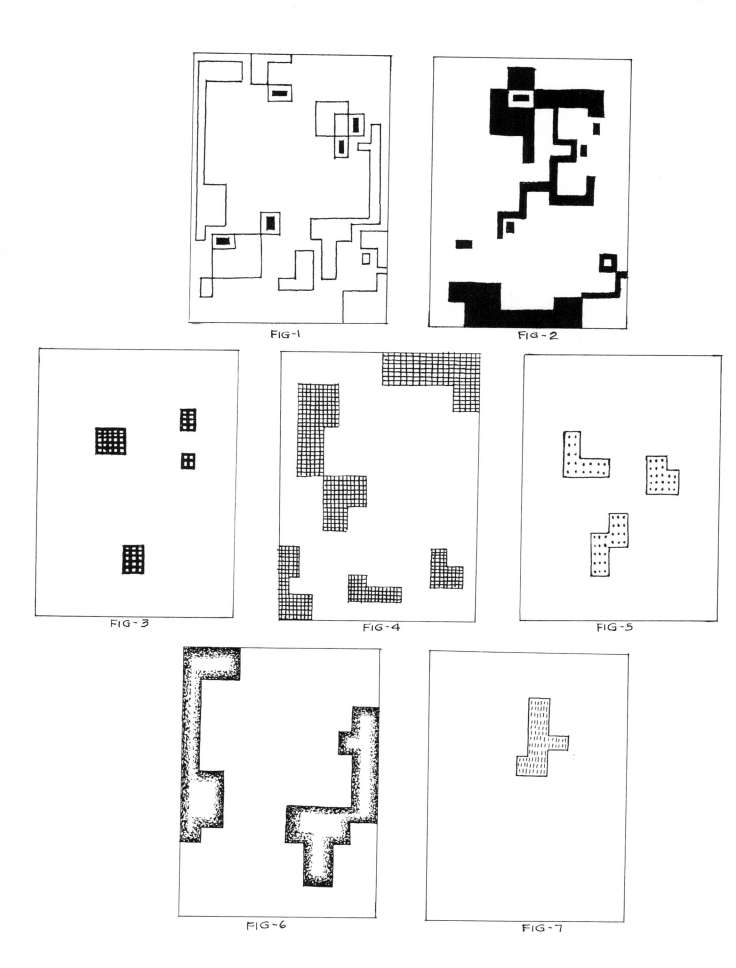

FIG-1

FIG-2

FIG-3

FIG-4

FIG-5

FIG-6

FIG-7

Pictorial Composition

PLATE 14

FIG-1

Figure 1 is one of the series derived from the same source material as Plates 13, 14, 15, and 16. When you analyze the composition, you realize that, unless the many different contour and tonal areas are controlled, the result will be an unsatisfactory arrangement. Remember that each different tonal area represents a different color. Even the same tonal areas may represent different colors, because the subtle differences in color changes cannot be adequately shown by black and white.

In addition to the suggestions in Plate 13, look for diagonal, as well as horizontal and vertical, motion. Since the actual lines are horizontal and vertical, the eye tends to move across and up and down. Any slanting motion adds tension to the design because it counteracts the effect of the rightangled lines.

Look for effective changes in the feeling of depth. Study, in particular, the two enlarged compositions on this plate. Even at first glance, not every part of the picture appears to lie in the same plane. Some parts advance more than others. Note the surrounding parts of the advancing areas and compare them with other parts of the design. This process of comparison of tonal areas and of the effect that adjacent ones have upon each another is similar to the comparison that has to be made in regard to color. Values and color have very little meaning to us as painters unless we relate the values and colors to each other. It is only under extraordinary circumstances that we ever see one gray or one color alone and without reference to any other gray or any other color. The painter soon learns how different a single color looks on his canvas, surrounded by other colors, from the way it looks on his palette, where it is isolated.

The Art of Pictorial Composition

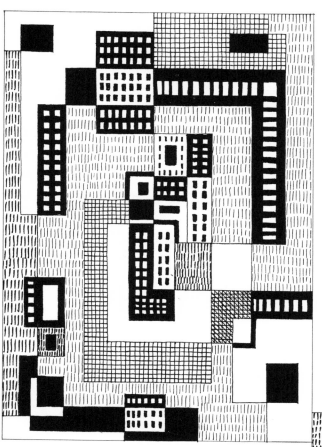

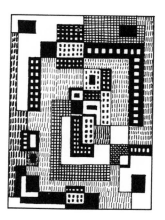

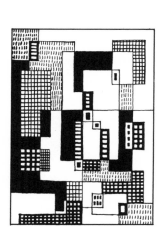

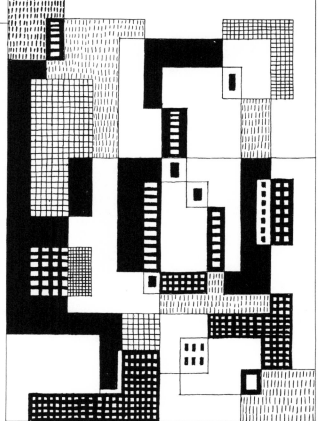

PLATE 15

To pursue further the consideration of the effect that adjacent tonal areas have upon each other, I have shown in Figures 1, 2, 3, and 4 four different tonal arrangements of the areas surrounding the dominant area in Figure A. The dominant area is unchanged in each figure.

Look through your own drawings and paintings and try variations in black and white and also color of small portions of your work.

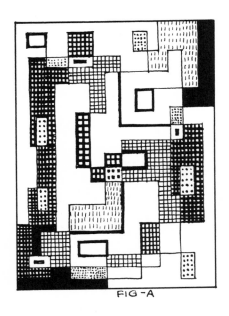

FIG-A

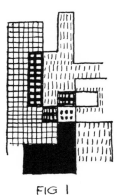

FIG 1

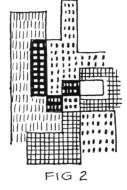

FIG 2

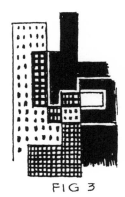

FIG 3

FIG 4

The Art of Pictorial Composition

Pictorial Composition

PLATE 16

FIG-2

Figure 2 is also derived from the same source material as Plates 13, 14, 15, and 16. Two small compositions and their enlargements are shown. Look at any one of the originals, which are the small ones; then study its enlargement. There is a noticeable difference between the two. While the enlargement is not mathematically exact, it is near enough so that the changes are negligible.

There are many reasons for the differences. One of the most important reasons is the inflexibility of white and black. No matter how small an all black or an all white area may be, when it is enlarged the area remains all black or all white. Any tone between black and white appears lighter when enlarged. This change in tone affects the relationships of the surrounding parts, particularly if all black and all white areas are involved. In terms of color, those colors approaching black—dark reds, dark greens, blues, purples, and browns—are least affected by enlargement. This also holds true for the very light colors in the yellow and orange family. Therefore, since a color's change affects its neighboring colors, enlargement alters the total effect of a composition. This is why the artist has so much difficulty making enlargements from color sketches.

Remember also that changes in color effect alter the emphasis of different parts of the picture area. When color takes the place of line, the same shapes in a composition are dependent upon color differences to bring out each area. The effectiveness of many shapes may be considerably reduced by a change in size. The painter must actually alter the color combinations in his enlargement, so that it will conform to the idea expressed in the smaller work.

The Art of Pictorial Composition

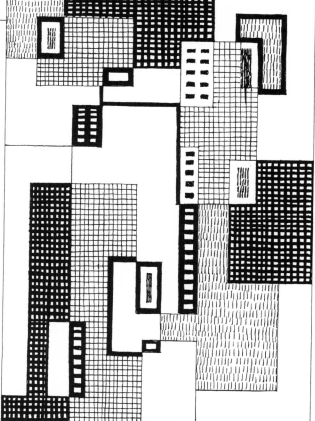

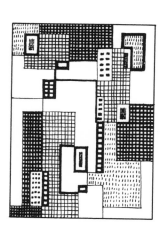

PLATE 17 Evolution of six pictorial compositions.

By means of Series A and B, I have attempted to show how the six compositions of this plate were evolved.

Series A emphasizes the large divisions and suggests the location of the area of chief interest in each picture.

Series B refines the large divisions by breaking them up into the components that will be the design of each.

The finished drawings of Plate 17 show the distribution of the value factors.

Study carefully the two series and try variations by taking some of the thematic material and transforming it to your own purposes.

The theme itself is relatively unimportant. It is what you do with it that counts. This does not mean that you should indiscriminately use the material that others have created. By all means, invent your own, but, if you do use themes not your own, try as far as you possibly can to inject something of yourself into the composition.

The noblest subject matter becomes trite in the hands of an inferior painter, while such matter-of-fact things as apples and old shoes become sublime in the hands of a master.

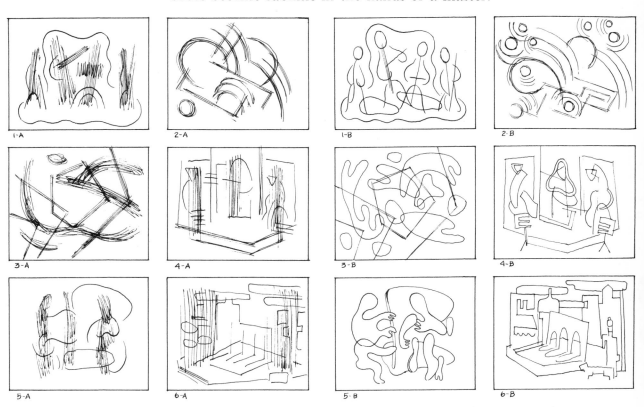

1-A 2-A 1-B 2-B

3-A 4-A 3-B 4-B

5-A 6-A 5-B 6-B

1

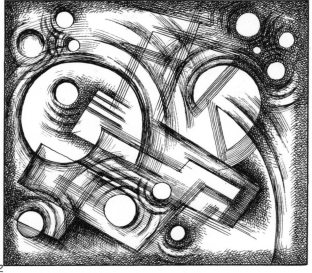

2

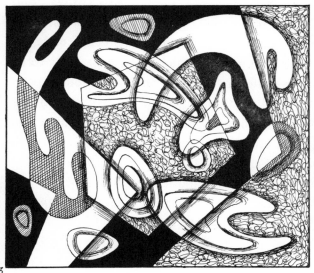

3

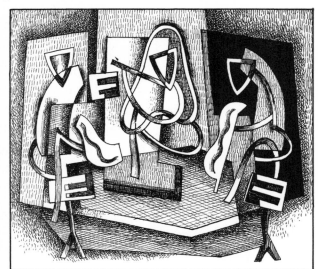

4

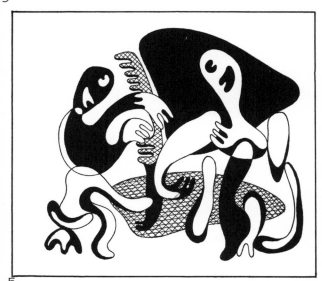

5

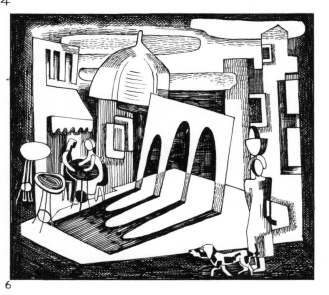

6

Pictorial Composition

53

PLATE 18 Variations on a triangular theme.

The two motifs used throughout each of the nine examples are the triangle ▽ and the quadrilateral. ◁ They are combined to form intersections; they are repeated in parallels; they are arranged to produce dominant directions; they are combined to show groups of dominant areas; they are used to show tensions and give the overall effect a dynamic quality.

From the very beginning, starting with pure geometric figures, I have thought of the nine variations in abstract terms, but since the plate was finished, every time I look at it now I cannot help thinking that the nine pictures show birds in flight. I don't see the triangles and quadrilaterals any more. Perhaps this feeling, in due time, will wear off. Of course, my change in reaction or your change in reaction, whatever it may be, does not alter the composition of each picture. I cite this to show that when we record our ideas in line and color the resultant work takes on character and life of its own. It is as if something new has been born, and, to each of us, it is a different thing at different times.

Variation A. Dominant and subdominant groups united by converging angles. Chief interest is in the lower part, although the converging lines add opposition and interest.

Variation B. Parallel groups with dominant opposite directions. A considerable degree of movement is thus expressed with the more dominant area on the right.

Variation C. Two principal groups are combined. The flow of line is more continuous than in Variation B. The general effect is of a calmer feeling.

Variation D.

Variation G. The grouping is quite compact in each of these

Variation H. examples.

Greatest opposition is shown in Variation D because of the converging angles, a device similar to the one used in Variation A. Variation G suggests some degree of radiation, with the focal area slightly above the center. Variation H shows opposition.

The Art of Pictorial Composition

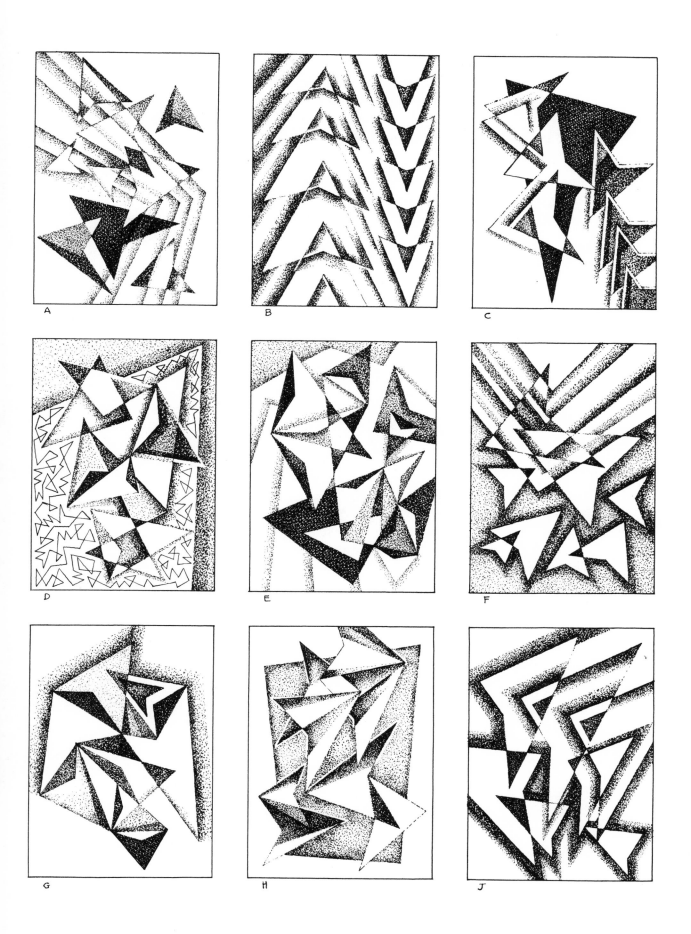

A

B

C

D

E

F

G

H

J

Variation E uses three large groupings tied together by means of the background diagonals. Tension is set up, in part, by the two areas of interest, one being the point on the right, the common vertex of at least seven triangles; the other being slightly above and to the left, where several triangles intersect to form a starlike effect.

Variation F. Various groupings occur, and the area of chief interest is enhanced by the diagonal angles. This composition looks busier than any of the others because space is subdivided into a greater number of units. There is a little more feeling of curvilinear flow here than in the others.

Variation J. In this picture, as in Variation B, parallelism plays an important role. The several systems of parallel lines set up dominant directions which induce tensions. The two principal areas of interest add a lively nervous quality to the arrangement.

The Art of Pictorial Composition

Unification of diverse units into compositions.

PLATE 19

In this plate each composition is assembled from the same basic material:

The five motifs represent simplified versions of natural and man-made objects:

1. Tree.
2. Trunk of tree.
3. Trunk of tree or telegraph pole.
4. House.
5. Fence posts.

Suppose that we now think of the five motifs as pure geometric shapes. Try to cast out of your mind any association with actual objects. Let us now reassemble our five motifs (Figure A).

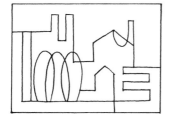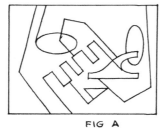

FIG A

The combinations are almost endless, particularly since the utmost freedom may be used in creating new compositions. One word of caution: Freedom of choice calls for control. Any array of lines and spaces based on the source material may be used, but if the resultant design has no sense of order, it becomes a discordant, self-defeating hodgepodge.

1. Liberal use has been made of repetition. Example 9 shows this clearly.
2. Some of the compositions show a single compact unit: Examples 5, 11, 12, and 15.
3. Some are arranged so that there are two principal divisions: Examples 3, 4, 6, and 7.

4. The diagonal flow of line is prominent in Examples 4, 5, 7, 11, and 13.

5. Horizontal flow is expressive in Examples 2, 9, and 15.

It cannot be emphasized too strongly that the flow of line, the just relationship of area shapes, color and value, and, in fact, all the other phases in picture-making must not be left to chance. This does not mean that you must wait until every minute portion of the space to be covered is completely settled in your mind. Composition very rarely is achieved in this way. A good way to proceed is to try to conceive in your mind's eye the general action or a part of it, then draw it, and go on from what may be only a modest beginning. However, as you continue to develop the composition, ask yourself about the character of the design that is being evolved. Carefully check whether parts are out of harmony. Try to retain an awareness of what is happening to your picture at each stage in its development. Do not depend upon accident for a good composition.

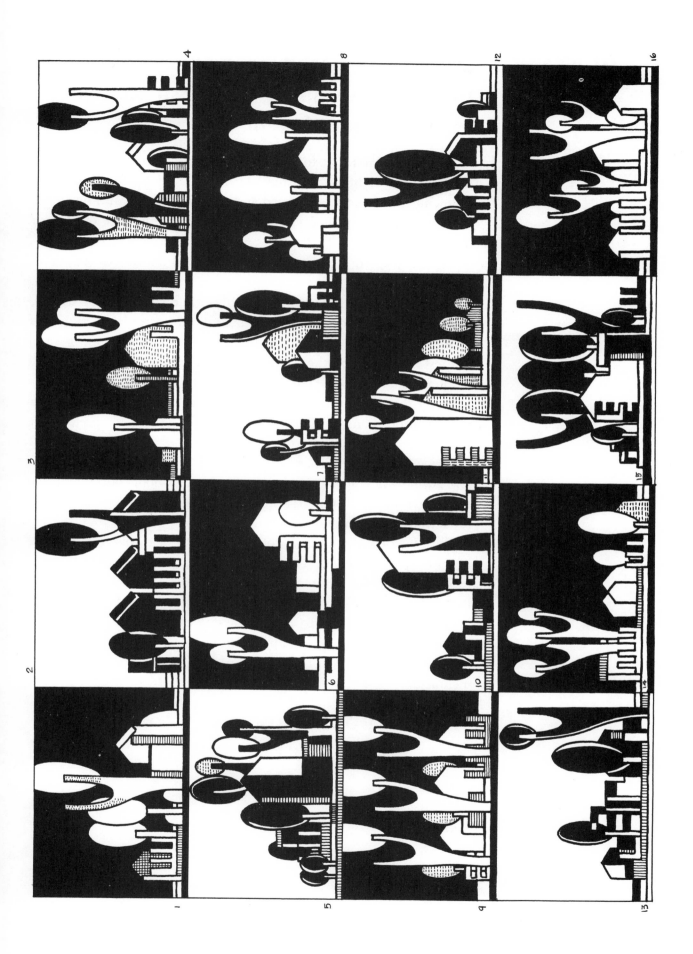

59

PLATE 20 Derivatives based on motifs selected from a composition (composition derived from outdoor sketch).

The source material for the 14 variations is shown in Figure A in the upper righthand corner of the plate. From Figure A, the following motifs were abstracted and then rearranged and repeated:

Figures 1, 2, 3, 5, and 11 show a decided dominance of straight lines.

Figures 4, 9, 10, 12, and 14 show a decided dominance of curved lines.

Figures 6, 7, 8, and 13 show more subtle distribution of straight and curved lines. In Figure 6 the overall effect of the straight-line angularity is quite striking, while in Figures 7 and 13 greater interest is centered in the curved portions. In Figure 8 almost equal emphasis is given to the curved and straight lines.

Study the distribution of lights and darks. Try to visualize how these compositions would look if the light and dark areas were changed.

This plate and the examples shown in the remarks to Plates 19 and 29 show how ideas that originate in out-of-door source material can be employed in the creation of compositions that in intent are far removed from the original material.

This, incidentally, is not a matter of liking or disliking any single type of expression in art. The ideas you have are yours; the thoughts, feelings, emotions, commentaries on life you may wish to portray in your work are distinctly personal. The question that always arises is this: How best to express these ideas? Without experimentation the question will remain unanswered. Too often little or no experimenting is done. There is no such thing as too much experimentation.

DRAW	DRAW	DRAW
COMPOSE	COMPOSE	COMPOSE
PAINT	PAINT	PAINT

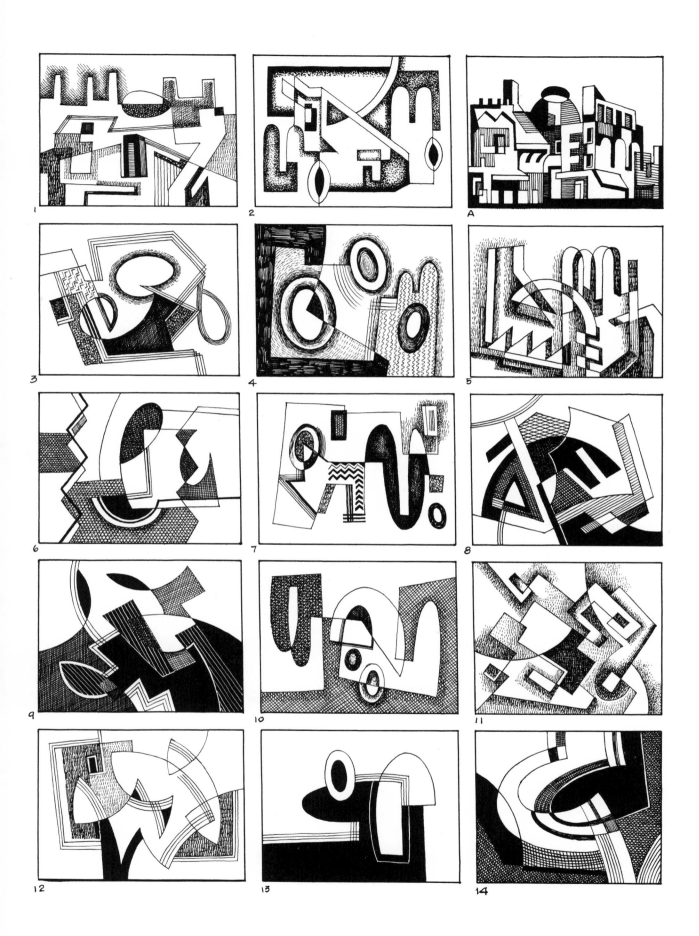

PLATE 21 Control of value key and area of chief interest.

Each of the 16 variations uses the same SIX values ranging from white to black, and the space divisions of each composition are identical.

In the high-key arrangements the light tones are dominant.

In the middle-key arrangements like Variation G, the middle tones dominate.

In the low-key arrangements like Variation N, the dark tones are dominant.

In compositions in which the tones are closely related in value, as in Variation C, the general effect tends toward the quiet and subdued, regardless of the key. Compositions in which marked contrasts of tone dominate have a greater shock value. They are more lively, expressing greater excitement and agitation.

Two good working principles are:

1. In closely related value painting, use horizontal and vertical lines and areas and try to avoid too many diagonals.

2. In tonal contrast painting, use diagonal lines and areas, the swirling line, and in general those devices that help create greater motion and excitement.

It follows from the above that, whatever the tonal arrangement, the feeling engendered by the flow of line, the sense of depth, and the character of the areas must be in harmony with the tone combinations.

Variation Q shows greatest contrast, with dominant black and white. If you wish to make an area of a composition more important, increase the contrast in value and chroma between it and its neighbors. If you wish to subdue an area, decrease the value and chroma contrasts between it and its neighbors.

In studying this plate, isolate any two compositions and note the differences in key contrasts, areas of chief interest, and focal spots.

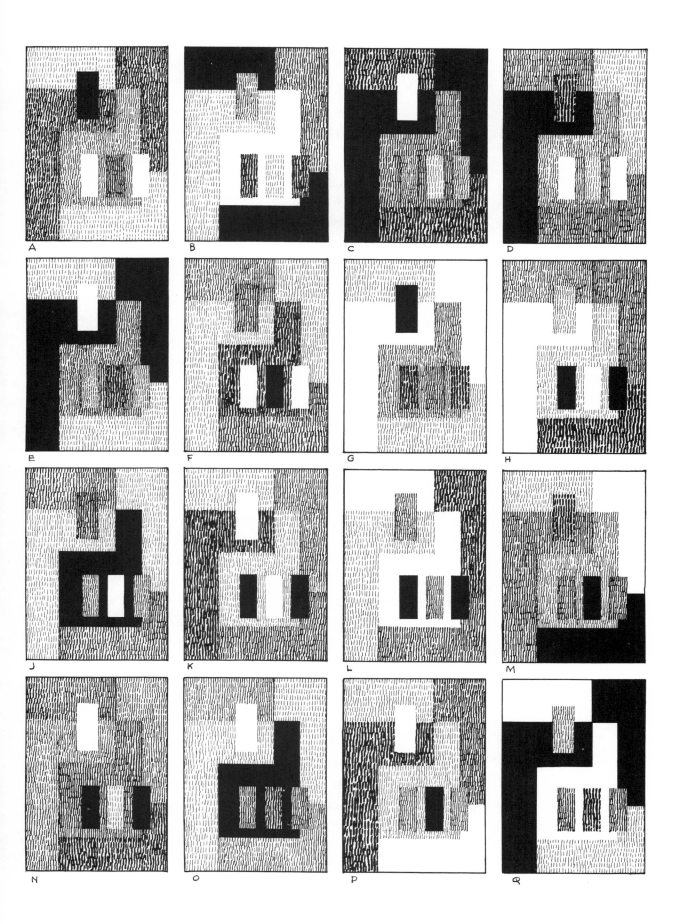

PLATE 22 Control of value key (change in mood).

Every color has its value equivalent. Every value, running the gamut from white to black, has its color equivalent in so far as we think in terms of color when we look at a black and white drawing or print. Many colors have the same value equivalent. Therefore, in transforming a black and white into a color composition, we may assign varying colors to the same values. There is no one color equivalent of a black and white composition, although there is one black and white equivalent of a color composition.

The most important aspect of the problem for us is the transformation into color of the sketches we make in black and white.

It is natural as we work from our own sketches of a particular object, to think in terms of its actual color. As we keep experimenting and trying for differences of effect and mood, we become less and less dependent upon actual colors.

When we work from an abstract composition, such as the one in Plate 22, there is no natural equivalent to form a basis for our color treatment. The color combination becomes pure invention and will be a reflection of the way in which we think and feel while we are working. Many subtle influences, most of them subconscious, will play their role in the choice of color. The sketch itself will act as the initial impulse and send us on our way.

Consider the four treatments of this plate. In the order of least to greatest contrast they are: 4, 2, 1, and 3.

The key of each variation has been changed. The relationships between corresponding parts of each variation have been changed. The mood of each variation has been changed.

As a result of the changes listed above, our reaction to each variation is different and our thinking in terms of color will be different.

Have you noticed that the shapes are identical in the four compositions? At first glance, this fact would not strike you because the differences in the compositions are more important and more impressive. It is only after you have studied the group that the similarities become clearer.

The Art of Pictorial Composition

1

2

3

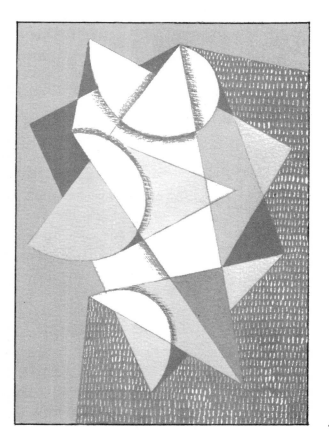

4

PLATE 23

One reacts differently in terms of color to the four compositions in this plate, not only because of the changes in key, mood, and treatment but because of the subject matter.

Figures 1 and 2 are abstract designs, and our reaction to their color will depend, in part, on whether they stimulate us to recall some color grouping from our past experience.

Figures 3 and 4 will definitely associate themselves with past experiences and act as an immediate influence on our color reaction.

From a practical point of view, it is probably easier to transform into color an abstract black and white composition than a realistic one.

Color is ever present, and every time the painter of a realistic subject uses color that is not natural to the subject, he must make a conscious effort to overcome his everyday sight experience. The conscious attempt to make his work more expressive by such color changes is a valuable experience, and continued experience gives the artist a feeling of freedom that he would otherwise not have.

On the other hand, working from an abstract composition gives the painter a sense of release. He is not dependent upon the limitations imposed by natural color restrictions. The difficulty of working from an abstract source lies in the fact that the artist must make up his mind about his color before he starts to paint. This is a difficult thing to do. It requires concentration, control, imagination, and freedom from fear. No painter wants to waste time, color, paper, and canvas, but if he does not overcome his fears, he may as well give up painting.

It is necessary to work in both ways. Painting from actual models, indoors and outdoors, gives the painter a wealth of experience in matching color, if nothing else. Working from imagination emphasizes advance planning and the expressive use of color combinations.

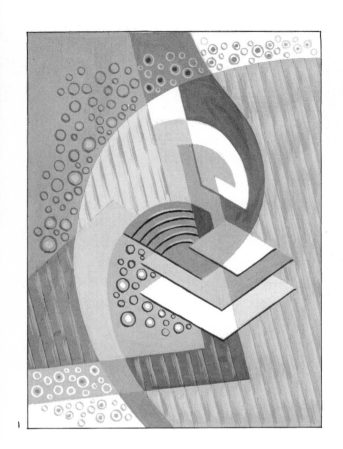

1

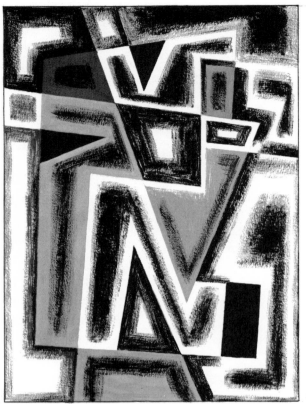

2

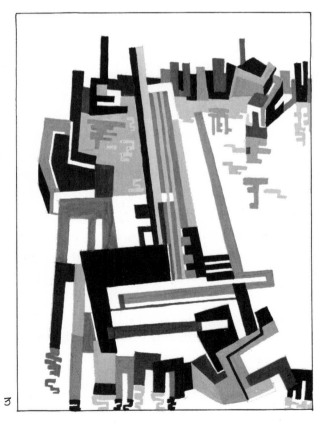

3

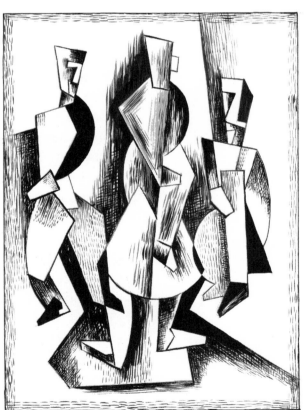

4

PLATE 24 Variations on a theme (union of two dominants).

Each of the six compositions is of a water pitcher and a bowl containing fruit. Two elements of equal or almost equal importance are combined to form various pictorial arrangements. Examples of this type of design are shown in Plate 26.

In Figures C and D the two elements are combined to form a single unit. The background detail is also concentrated to unite with the area of chief interest. This concentration tends to create a very compact kind of design. Because the area is large, a focal spot is advisable. In both examples this spot is the area in the bowl containing the fruit. The parallel lines in the background add variation in both rhythm and space shapes. Care must be taken not to make such secondary areas too lively lest they detract too much from the chief interest.

In Figures A, B, E, and F there is a link connecting each of the two units. The link is not just a random black or gray area joining the pitcher and the bowl, but a shape that is derived from the forms within the principal interest. In a sense this is a type of repetition. Its virtue lies in the fact that greater homogeneity is achieved.

In Figure A there is a sense of angularity which pervades the whole arrangement. The feeling of sameness tends to unite all the parts, further illustrating the power of repetition.

In Figure B the curved lines and areas in the table are repeated in the background figures. These areas and curves stem from the curves and areas of the fruit bowl.

Figure E, which bears a close resemblance to A in so far as the position and general treatment of the fruit bowl and pitcher are concerned, places greater emphasis on the diagonal direction. For one thing, the difference in size is intentional in order that the diagonal may assert itself. If you study the variation, you will discover many diagonals. In some respects this quiet design is the most dynamic of all in this plate.

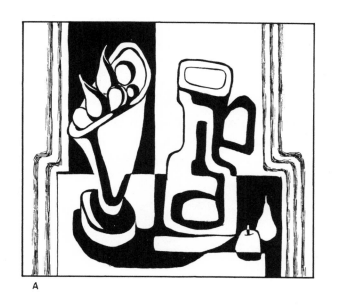

A

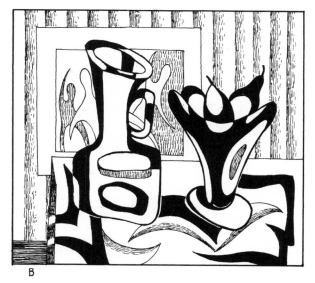

B

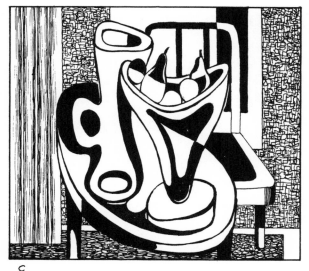

C

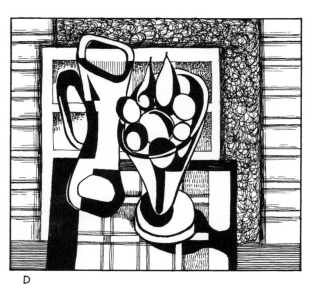

D

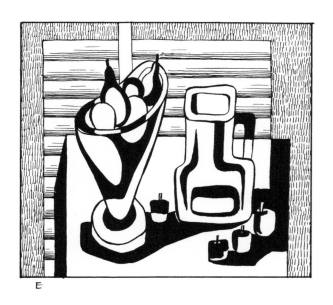

E

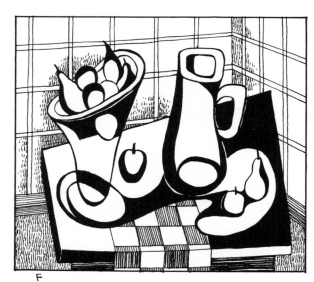

F

In Figure F, emphasis has been added to the pitcher by means of the converging background lines. The distortion in the rear line of the table (as compared with the other compositions) also heightens the sense of motion toward the pitcher. The contrast between the foreground and the background, both in value and space division, is quite marked, more so than in the other examples.

From Variation C I have created two thematic arrangements that introduce rhythms differing from those in C.

PLATE 25 Variations in treatment and mood of a theme (based on outdoor sketch).

The five variations on this plate show how I reacted pictorially to a scene that I had observed many times and that I had sketched: sometimes with great freedom of stroke, omitting much detail; other times working with great care to include as much as possible.

Every painting has its own genesis in a fact-finding period. "Fact-finding" means learning about something. What the artist does with the facts is another story. Ignorance cannot be concealed, but, fact-finding can be carried to an extreme until it becomes ridiculous, despite Ruskin's dictum that if the artist paints a group of rocks, the rocks should be rendered so faithfully that a geologist could ascertain all sorts of geologic information from the painting.

Variation A expresses the greatest realism, even though a simplified motif inherent in the original combination of lines is used. Various houses are defined quite clearly; the tree is unmistakable in its delineation, and the railroad crossing detail is clearly expressed. The chief interest is centered in the middle of the composition, comprising the tree and the houses associated with it.

Variation E shows greater simplification than Variation A, with the composition divided by the tree into two major parts and the chief interest is concentrated on the lower right side. Diagonal rhythms on the left side and vertical rhythms on the right side offer contrasts that enliven the design.

Variations B and D are compositions that emphasize lights on the "stop" signpost. In Variation B, vertical and diagonal lines dominate, with an important secondary interest suggested by the tree. In Variation D the general interest is contained within a more concentrated area. The horizontals in the sky and in the foreground balance each other.

Variation C leaves all semblance of reality behind. The interest centers on an attempt to show the clamor, noise, and turbulence of a station and the frightening earth-shaking approach of a train. The ringing sound of the warning bell pervades everything. I purposely chose a long rectangular space to help suggest the continuance of sound vibration.

The Art of Pictorial Composition

A

B

C

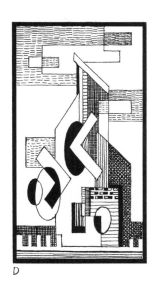

D

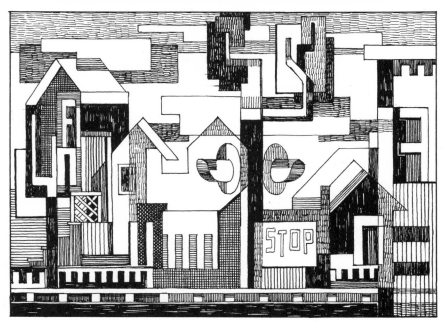

E

PLATE 26 Control of two dominants.

In each of the four examples there are two important dominant areas. The dominants are united to form continuity. However, the dominants are not of equal importance. Generally speaking, when dominant areas claim the same attention, they tend to negate one another. If the composition has nothing beside the dominants upon which the eye can focus, a situation arises in which there is no overpowering claim of attention. This results in a composition that lacks decision. It is the same as if a number of people are talking at the same time with equal loudness. No one is heard or understood.

If there is only one dominant area, the problem of focusing attention takes care of itself. If two or more areas are of equal importance, these areas must be made to balance and something must be added to claim chief attention.

If the areas are not of equal dominance, the more important one becomes the dominant.

Figure 1. The two dominant areas are very obvious in this arrangement, with the more important one on the left. Each dominant, upon examination, has its own character, adding variation to the design as a whole. The dominants are united by the curved lines of the foreground and the converging rays and horizontal clouds of the background. The curved lines of the foreground are quite closely related to the curves of the dominant areas. In contrast to this is the treatment of the sky, which is markedly different. Draw your own conclusions as to the symbolic meaning of the foreground and the background.

Figure 2. The division between the two dominant areas, while clearly defined, is less marked than in Figure 1. The composition, as a whole, is homogeneous. The areas throughout the whole design are closely related in shape and treatment. The principal contrasts in value and space delineation are more pronounced in the figure on the right and its surrounding areas.

Figure 3. The two dominant areas in this arrangement are closely allied by the lines and areas in the table that joins them. Furthermore, the background treatment adjoining the lower bowl is quite

1

2

3

4

similar to the space division of the background next to the bowl on the left. The rather light key in the right bowl is in keeping with the same key treatment in the right background. The darker key of the left bowl and left background offers contrast that tends to help distinguish the relative importance of the dominant right bowl.

Figure 4. In this rendition of a New York scene with the Brooklyn Bridge in the background, the composition is divided almost equally between the dominant area on the right and the subdominant. The flow is controlled so that the eye travels from the right diagonally across the lower part of the picture up to the left, then over to the right into the upper part represented by the bridge.

In each of the four variations, consider each of the dominant areas in relation to the other; then study each area alone by placing a sheet of paper over the other area. Look over the space relationships, light and dark variations, and area treatments, and then try to imagine suitable color combinations which you think might be consistent with the general feeling engendered by the composition.

This is a discipline that is worth developing because it heightens one's sensitivity to color treatment and one's power to express mood with color.

A further example of a composition involving the control of two dominants is on the opposite page.

PLATE 27 Imaginative compositions based on sketches (control of dominants).

In Figures 1, 2, and 3 there is a dominant area composed of two parts so united that the general effect is that of a single unit. In Figure 1, human figures compose the two parts of the dominant area.

In Figure 3 the human figure is one of the two units; the other unit is the table with the potted plant. The two units, while different in subject matter, are tied together to form the dominant.

In Figure 4 the two units are: first, the human figure on the left; second, the combination of plant and human figure on the right. The three elements make up the dominant area.

In Figures 1, 3, and 4 the background plays a role of varying relative importance. In Figure 3 the background is more vital to the composition than are the backgrounds of Figures 1 and 4.

This does not mean that the function of the background can be dismissed. Every part of a composition is important. It is a matter of degree. If the background can be eliminated entirely without altering the essential quality of the picture, it does not belong there in the first place. The type of composition represented by a compelling dominant and a relatively minor subdominant or background is eye-catching. The observer is immediately brought to the statement made by the artist. This type of design is more obvious than that of Figure 2.

In Figure 2 the dominant area is composed of the human figure and the two cars. Notice that this group is treated with curved lines and the areas are smooth-flowing. In contradistinction to this treatment is the angular rendition of the background. The background is made up of two principal parts, as is the dominant. The left side of the background is the more important while the right side, or human figure, of the dominant is its more important side. The shift in importance from right to left creates a dynamic quality.

The Art of Pictorial Composition

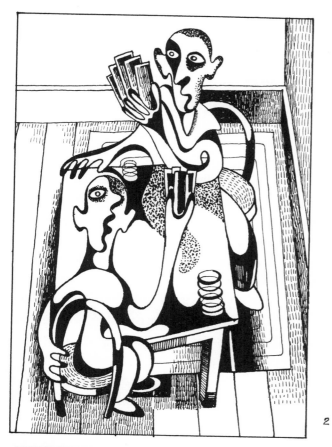

1

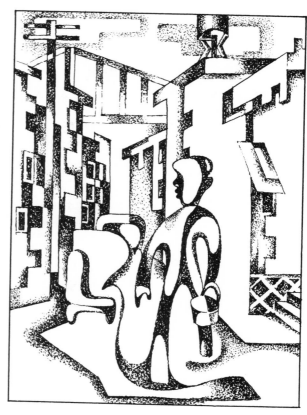

2

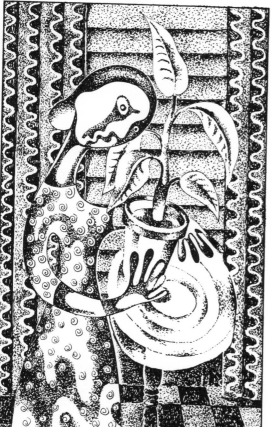

3

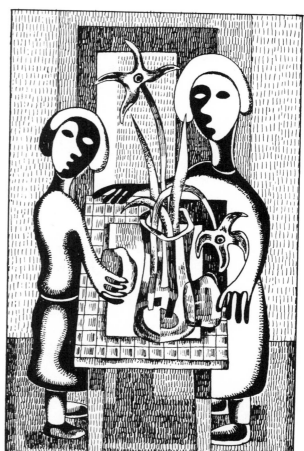

4

PLATE 28 Selectivity in composition from nature.

Except for Figures 2 and 7, which were drawn in Gloucester, Massachusetts, the other marine and boat compositions represent scenes in Wellfleet on Cape Cod. The eight pictures shown in this group are the result of a considerable amount of selectivity. Working from nature means leaving things out. It often means rearranging the relative positions of the parts that are left in. Working indoors from imagination and from material gathered outside, we reverse the process. Putting things into the composition is the order of procedure. Since the sketches are simplified versions of nature and since we cannot possibly remember all the things seen, only those that vividly impressed us remain with us long enough to be used.

The painter cannot always have recourse to models. If he limits himself to outdoor painting, as some of the impressionists did, he may introduce mental blocks that will impede his growth.

We may safely say that the artist must store up, for future use, his experiences, his study of natural forms, and his experiments in composition and color. Obviously this means that the painter must observe, draw, sketch, and paint from the model as well as from memory, and he must keep on doing this. Every artist reaches a point in his work where he begins to repeat himself too much. He has exhausted his ideas; his point of view has lost its freshness; he has become stale. When this happens, the artist must take stock and ask some self-searching questions. A period of introspection must follow. This results in renewed interest in source material, a new excitement creeps into each effort, and the painter has a new lease on his artistic life.

DRAW from the model COMPOSE from the model.
DRAW from memory. COMPOSE from memory.

Figure 1. Balanced diagonals in opposition to dominant intersecting horizontals and verticals.

Figure 2. Dominant diagonals and verticals with subdominant horizontals.

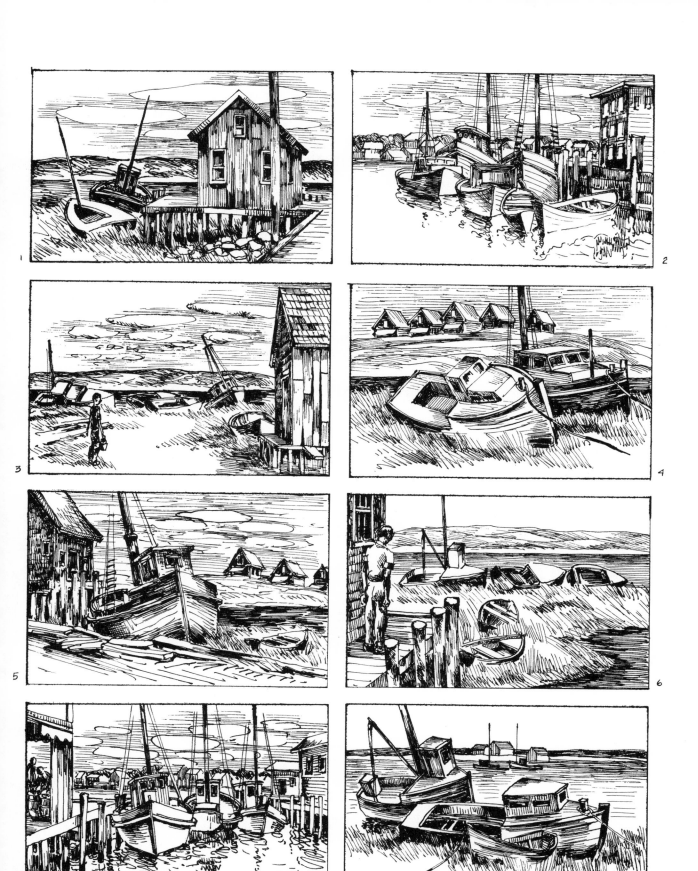

Figure 3. Dominant area on right with off-balance diagonals. Partial balance of left and right tied together by horizontals.

Figure 4. Dominant foreground area with subdominant background, united by curved line of flow and diagonal.

Figure 5. Dominant diagonals with chief interest area on left, with subdominant area of houses in opposition.

Figure 6. Parallel horizontals in opposition to parallel verticals, with diagonals increasing the sense of movement.

Figure 7. Dominant diagonals and verticals, with horizontal of lesser interest. This variation is closely related to Figure 2.

Figure 8. Dominant diagonal, with chief interest massed in foreground. Background of intersecting horizontal of secondary interest.

On the opposite page another group of drawings are shown that have been taken from my outdoor sketches. You analyze the compositional structure.

PLATE 29 Derivatives from selected compositions.

Six of the eight compositions on Plate 28 form the basis of this plate. Three variations of each of the six arrangements are shown.

In each case the essential linear design, as described in Plate 28, is retained. There has been considerable change in the relationship of light and dark and in the focal area. It should be noted that the mood of a picture is closely related to line and tone treatment. Incidentally, the sense of realism, or recognizability of subject matter, has been retained even though there has been rather free use of the form in many of the examples.

Each example contains rhythms that may be used to great advantage in creating new compositions.*

For instance, consider Figure 7. Some of the rhythms are the following:

There are many more combinations, of course, and it becomes a problem of choosing the rhythms that will best suit your purpose.

We may now rearrange the selected rhythms to form new compositions. The amount of realism you retain rests entirely with you.

 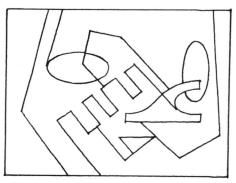 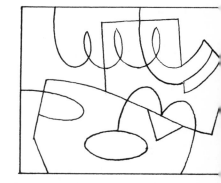

FIG A

* Plate 20 is based on the procedure shown here.

 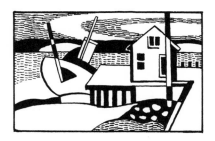

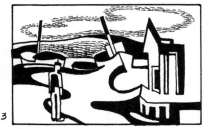 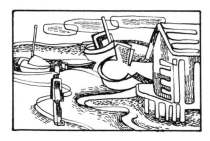 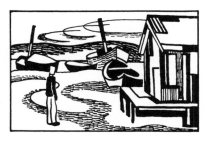

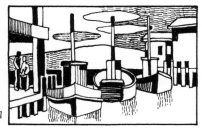 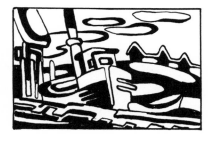 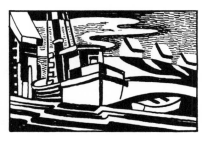

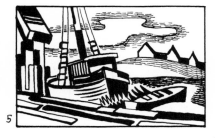 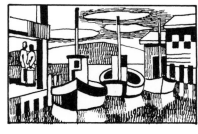 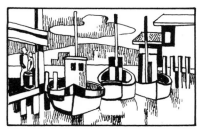

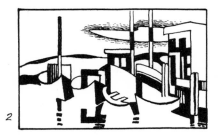 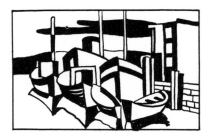 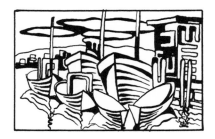

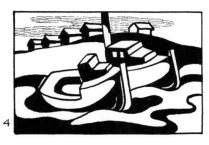 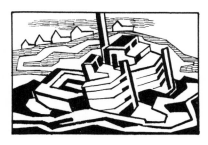 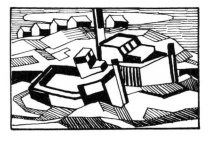

PLATE 30 Analysis of compositions (compositions derived from sketches made from nature).

Figure A—"Merry-go-round." This composition comprises a dominant area composed of human figures and a subdominant area suggesting billboards. The dominant area shows a group of vertical lines united with curved lines.

The subdominant area also uses a group of vertical lines united with horizontal lines. In conception and treatment it is much simpler than the dominant area.

Within the dominant area is the chief center of interest. It is the area showing the large figures holding the children.

The curved lines of the base of the merry-go-round and the contours of the shadows harmonize with the curved lines uniting the human figures. The curved lines are an interesting contrast to the important vertical lines of the figures and poles.

The wooden horses identify the setting of the composition but in general play a minor role in the overall arrangement. The decorative treatment of the manes and tails of the horses produces rhythms that differ from the rhythms set up in the human figures. The repetition of rhythms in the animals is so arranged that they balance, leaving the chief interest in the human figures.

In the brief description of Figure A, I have dwelt chiefly on the large aspects of the dominant and subdominant areas. The composition as a whole is very involved, and much more can be said about the numerous parts which are important, even though unobtrusive.

Figure B—"The Conference." The extreme contour in essence is elliptical. For the most part, the various subdivisions are also elliptical. The repetition of the same general type of area adds considerable unity to the composition as a whole. We may also view this picture as a design made up of two dominant parts united by similar curved lines and curved areas.

Remember that when we analyze a composition, each part, when considered apart from the rest of the design, assumes an importance that it neither actually has nor is meant to have. Therefore, the dividing line considered in Figure 1 above must not be made too important by the painter.

The Art of Pictorial Composition

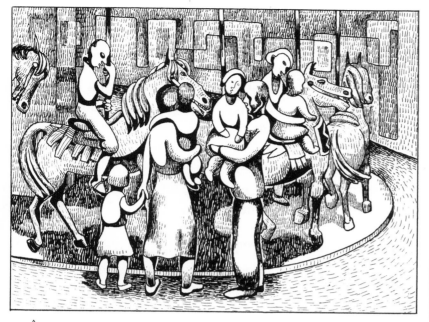

A

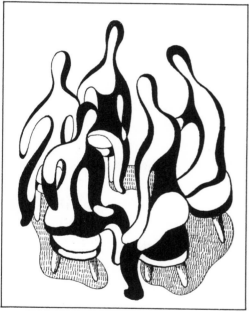

B

D

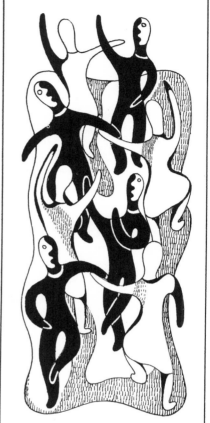

F

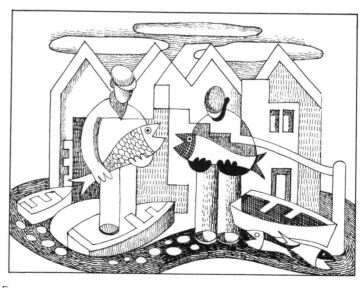

E

C

Figure F—"Swing your partner." This composition is a combination of several rhythms. The most important are the vertical and the diagonal. The vertical is expressed in the upright dancing figures and is united by the outstretched arms (Figure 2).

The diagonal rhythm derives from the alternation of dark and light figures. Beginning with the dark figure on the lower left, the eye travels diagonally up to the right to the second dark figure; then it moves up to the left to the third dark figure and finally up to the right to the fourth dark figure (Figure 3).

Other rhythms that give a unique quality to the composition are composed of a series of almost similar curved lines which vary principally in direction (Figure 4).

Figure E—"Fishermen." This is essentially a composition that has a major dominant area, a minor dominant area, and a background subdominant area uniting the two dominants. If one looks quickly, the design seems to be symmetrical about a vertical axis, but on looking again, we see that there is no repetition anywhere in the composition. Some of the shapes are somewhat alike, but there is enough difference to maintain a sense of asymmetry.

The essential rhythms of Figure E are broken down in Figures 5, 6, and 7.

In Figure 8 the light and dark areas have been changed so that the chief dominant is now concentrated in the fisherman on the left. The wider use of extreme contrasts of black and white helps change the mood of the composition. Compare Figure 8 with Figure E in Plate 30. The linear treatment in each is the same, but in every other respect, striking changes have been made.

(Plate 21 deals with the general problem of keeping the areas in a composition fixed and of changing the emphasis and mood by redistribution and repetition of light and dark values.)

Figures C and D are two of a series included elsewhere in this book and were redrawn from sketches made outdoors. They may be used as the basis for experimentation in composition and color, but I urge you, whenever possible, to create your own material by drawing, sketching, and painting anything and everything.

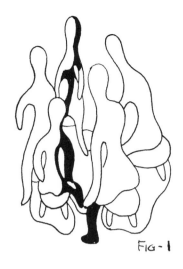

FIG - I

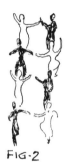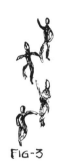

FIG-2

FIG-3

FIG 4

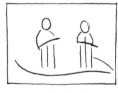

FIG 5 F,IG 6 FIG 7

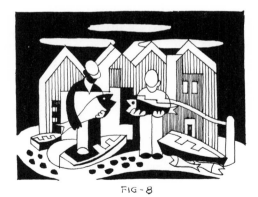

FIG - 8

PLATE 31 Realism and modified realism, based on street scenes (selective composition).

This plate can be divided into two groups: C, D, and F; A, B, and E.

Figures C, D, and F are realistic in concept and rendition.

Figures A, B, and E are quite abstract although the general effect in each borders on realism.

Figure C is a coalyard near a railroad station. Contrasting lines are vertical and diagonal. The diagonal lines of road, eaves, and clapboards lead out of the picture, counterbalancing the vertical lines of coal storage bins and the diagonals of coal chute and wooden supports. The chief emphasis is the storage building. The direction in which the clouds are traveling tends to be opposite the direction of the diagonals of the buildings and road. This enlivens the aspects of movement in the composition.

Figure D. In this quite realistic rendition of a New York City demolition scene, the contrast between the triangularity of the figures taken singly and in combination and the squarish, right-angularity of the buildings is quite marked. Part of the diagonal quality of the figures is carried into the alignment of roof corners, creating parallelism of direction. In this particular composition it would be a simple matter to change the emphatic focal areas by increasing or decreasing the amount of value contrasts.

Figure F. As in Figure C, the principal lines are vertical and diagonal. This time, however, the diagonals for the most part converge within the rectangular space, setting up an important focal area. Tension is set up by means of the diagonals of the elevated structure, which veer off in another direction. There are many more vertical lines in this composition than in Figure C, but they do not dominate as they do in Figure C. This shows how mere numbers of lines do not necessarily create dominance.

Figure A. If you examine this composition of a New York street scene, you will see that a basic motif is repeated over and over again. Variations in size, direction, and relative proportions of the motif help in building the design. The general effect is quite realistic in the sense that the representation is an unmistakable

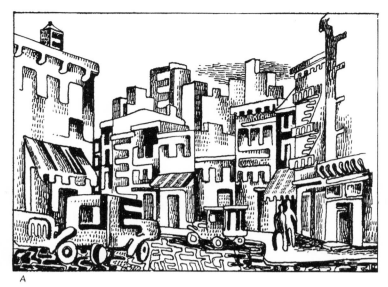

A

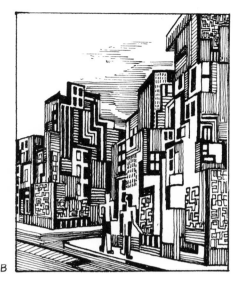

B

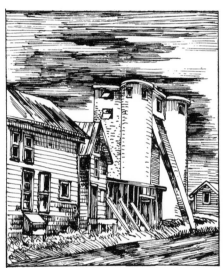

C

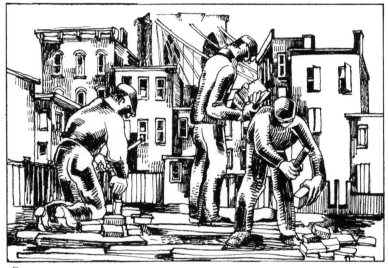

D

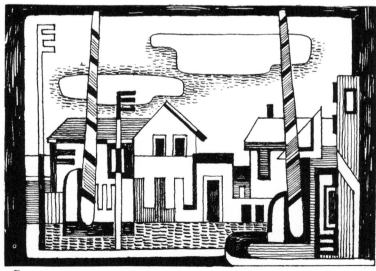

E

F

Pictorial Composition

91

street scene. The automobiles and figures, by and large, use the same motif. This is a further illustration of the use of repetition in building a composition. The lights and darks are just about equally balanced with a little greater emphasis on the left, in the area of the awning and automobile. (Greater contrast would improve this composition.)

Figure B. Vertical and diagonal lines dominate this street scene. One of the dominant motifs is ⌐ which is repeated in various ways throughout the composition. While the general effect is realistic, as in Figure A, each part is abstract in treatment. The figures carry out the general feeling of angularity and may be regarded as the area of chief interest. Perhaps additional contrast around the figures would emphasize them a little more, but a little sublety does not hurt a design.

Figure E. This is the railroad crossing at Kingston, New York. Obviously, this is a stylized treatment in which two elements, each containing a railroad crossbar, are united by a series of horizontal and vertical lines representing the street and houses. The unit on the right is the more important, with the area of chief interest concentrated in the lower right. The various rhythms—such as the parallel blacks on the crossbars, the diagonals giving a triangular effect, the parallel horizontals—are generally so arranged that they balance.

Two more figures, one realistic and one abstract, appear on the next page for your consideration.

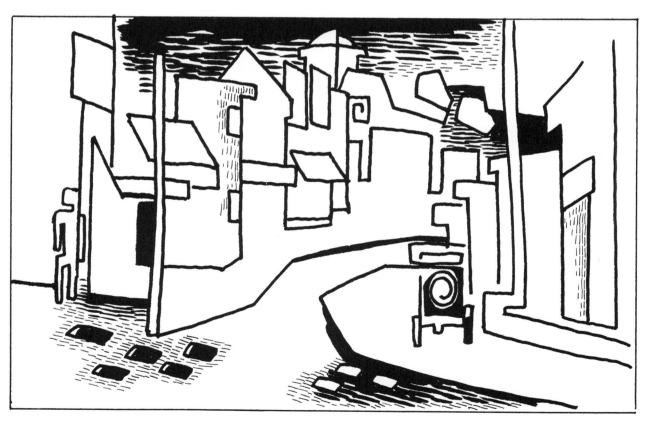

PLATE 32 Developments from selective compositions (sketches from nature; source material).

Figure 1 is essentially made up of groups of horizontal and vertical lines. This results in combinations of rectangular areas. The two large divisions comprise the dominant, containing seated figures, and the subdominant background of boats, wharf, and distant hill.

Any regular repetition of lines of action or areas tends to unite the design as a whole, although there is always the possibility that too much repetition may result in monotony. One of the problems that each painter must decide for himself is at what point in the development of his picture he has overemphasized the basic patterns. As you gain in experience, you become more aware of the limitations of repetition. This is not to say that repetition as a fundamental device is not of the greatest importance. I speak now of too much of it.

Figure 2 combines triangulation with the horizontal and vertical. The result in this picture, as compared with that of Figure 1, is greater variety and more action. Triangular, trapezoidal, and rectangular areas are combined, giving a sense of change and action. Care has been taken to make the triangular and trapezoidal areas stand out. Remember that if all the parts are of equal value, a focal area is missing. Then there is no resolution to the design, and it is indecisive.

Figure 3 is quite closely related to Figure 1 in so far as the most vital elements of the design are essentially horizontal and vertical. The dominant area is striking, and in the black and white version, as you see it, there may be some question as to whether the two figures grouped on the left or the horse on the right is the more important. My own feeling is that the horse claims our greatest attention, and it was so intended. The subdominant, as well as part of the dominant, contain important oblique lines which interrupt the continuity of the repeating horizontals and verticals.

The Art of Pictorial Composition

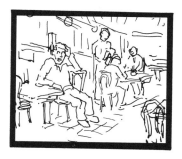

2

1

3

The four small compositions are part of a series that appear in other parts of this book. They are from my collection of many hundreds to which I have added from time to time, as I wander about with a sketchbook in my hand. Use your own material, of course, but if the figures in this plate or any of the others will help you in any way, by all means make the most of them.

The Art of Pictorial Composition

Skeletal compositions derived from organized groups.

PLATES 33 and 34

The compostions illustrated in Plates 33 and 34 are derived from Plates 17, 26, 28, 31, 35, and 37.

I would like to emphasize the way in which the various drawings on Plates 33 and 34 were made. Originally the landscapes, street scenes, fishing scenes, and boat pictures were sketched out-of-doors. Incidentally, in the course of many years I have accumulated thousands of drawings, notes, sketches in black and white and in color. Some are hardly more than fragments representing a fleeting moment. Others are highly finished. They represent almost every variety of subject matter and have been a constant source of material for development into larger works in oil, casein, and pure aquarelle, and etching. I kept these sketches, adding to my collection by drawing-out-of-doors and from the figure at every opportunity. In addition, I make it a practice to work from memory and imagination. I have been pleasantly surprised to find that a sketch that was hardly more than a mere statement, and which I was tempted to destroy, became the inspiration at a later date for a series of new ideas. We never know how we shall react to the material we gather. It is important to hold on to all the work we do because it has entered into our experience and at some unexpected moment may be used to advantage.

Getting back to the steps in which the drawings were made:

1. Sketch made from actual objects.
2. Simplified linear designs made from originals, experimenting with various types of composition.
3. Finished drawings and paintings from the color notes, sketches, and linear compositions.
4. The ink drawings illustrated in Plates 33 and 34 were made from the finished drawings.

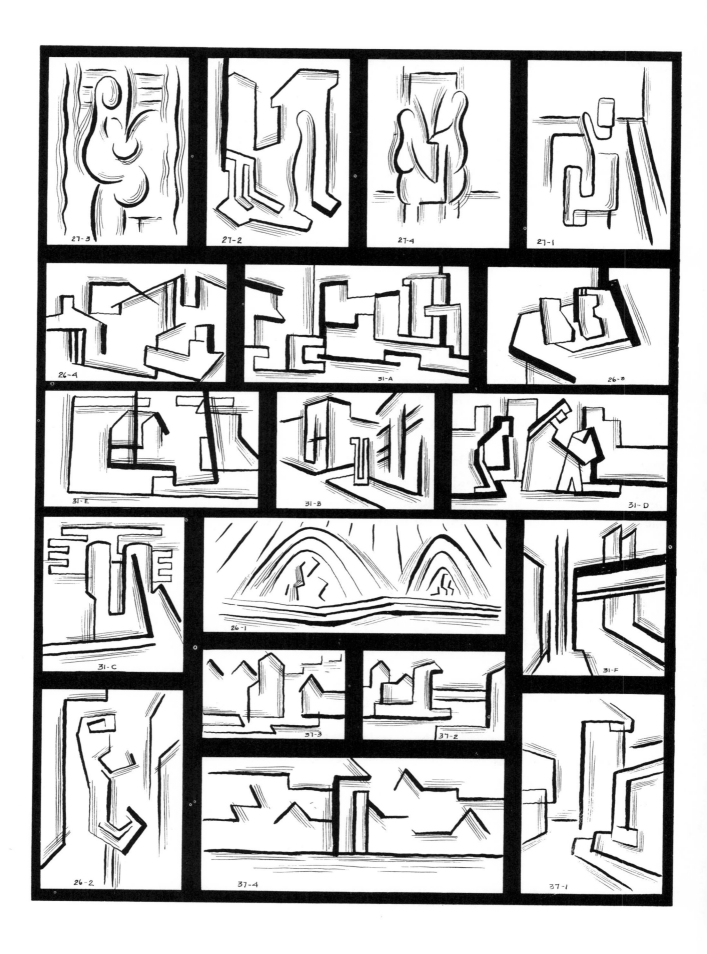

The Art of Pictorial Composition

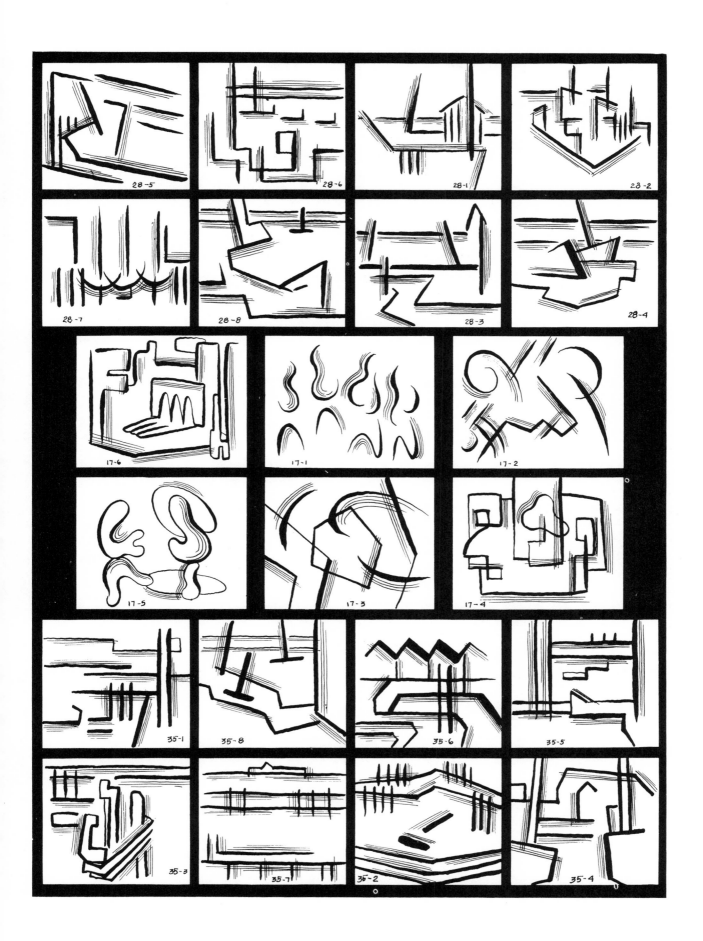

Pictorial Composition

In the process just described, the various results are derived from source material that is available to everyone. In general, I would call this a realistic approach to composition even though the result may be quite abstract.

The skeletal arrangements of Plates 33 and 34 must not be viewed as mere afterthoughts or accidents. They help highlight some important aspects of the finished drawings.

These skeletal ink drawings are essentially the same as the designs in Step 2.

We may use any one of these designs as a starting point, independent of other considerations, and proceed by a series of rearrangements to create from it a set of new compositions.

The Art of Pictorial Composition

First developments from selective compositions.

PLATE 35

Each of the eight examples in Plate 35 has been used as the basis for two variations on Plate 36.

Begin with Figure 1 of Plate 35. The principal lines are horizontal and vertical. The chief diagonal line of the foreground offers contrast and leads into the composition to the area of chief interest.

Note in Plate 36 the two variations of Figure 1. Both are simplified considerably but retain the salient horizontal-vertical character of the original. The diagonal is effectively used to highlight the area of chief interest. If you compare the two compositions in Plate 36, you will find considerable difference in the shapes of the small areas and in the position of the area of chief interest.

Figure 2 of Plate 35. The chief flow of line is diagonal, counterbalanced by parallel vertical straight lines in the upper part and curved parallel, almost horizontal lines in the lower part.

In Plate 36 the variations express in simplified form the essential flow of line which is an integral part of the original. The positions of the dominant areas differ in each variation.

Figure 3 of Plate 35. The foreground group, consisting of a dory and three figures, is the dominant part of the composition. The general contour of this group carries out the basic triangular shape of the figures. The vertical direction of the middle figure is repeated in the wharf in the middle distance. The horizontal background acts as a counterbalancing direction. One of the most important directions in the composition is shown by the diagonal of the foreground boat. The two variations in Figure 3 of Plate 36 carry out the sense of triangulation in the foreground, counterbalanced by the horizontals and verticals of the middle distance and background.

Figure 4 of Plate 35. The composition as a whole is subdivided into two principal parts, united by parallel transverse lines in the lower foreground, middle distance, and background. A further feeling of unity is produced by the sloping lines of the masts and roofs of the houses. The sloping lines do not meet within the limits of the picture. However, they create the feeling that if prolonged, they would meet, if not in a single point, in points close enough

together to form a focal area. Greater emphasis can be given to either large division by an increase in value or color contrast.

In the two variations in Figure 4 on Plate 36, the essential character of the original is retained: two dominants, united by transverse lines, and a general convergence toward a single area of interest.

Figure 5 of Plate 35. The chief interest lies in the central group of boats. To the right and left are units suggesting houses and trees. These two units are treated in an almost similar manner, thereby reducing the powerful effect of either one. The parallel lines of the foreground and background help to create a unified whole.

In the variations in Figure 5 on Plate 36, the general character of the original composition has been changed somewhat by bringing the boat motif closer to the building on the right. We now have two compositions, in each of which there is a large dominant and a large subdominant, instead of, as in Plate 35, a dominant flanked by two almost equal subdominants.

Figure 6 of Plate 35. In this picture the foreground claims our attention first. The eye is then led into the picture by the curving lines to the houses. We have two different themes united by curving lines. We can control the area of chief interest by changing the flow of line and by altering the amount of color and value contrast.

In the variations in Figure 6 on Plate 36, the division between the two motifs is maintained, although the background and foreground themes in the composition on the right are more closely related.

Figure 7 of Plate 35. This is a composition in which a vertical dominant group is united by two parallel horizontals. The foreground horizontal is connected with part of the vertical dominant, and the background horizontal is also connected with part of the vertical dominant. We may also think of this picture as composed of two parallel dominants united by a vertical. The chief emphasis can easily be controlled by means suggested in the preceding analysis.

In the two variations in Figure 7 on Plate 36, the emphasis has been shifted so that in the left variation the dominant is united with the lower horizontal, while in the right variation the dominant is centrally located, creating an area of chief interest which embraces part of the upper horizontal as well as the lower. Note the difference in flow of line in the two variations and compare with the original.

Figure 8 of Plate 35. This composition may be regarded as a

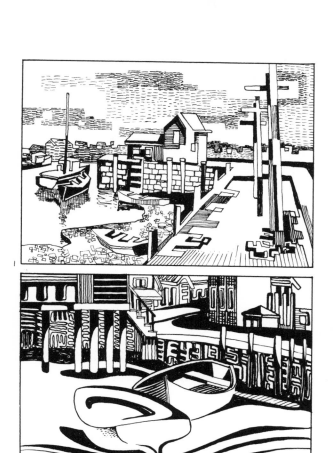

1

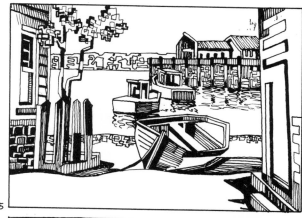

5

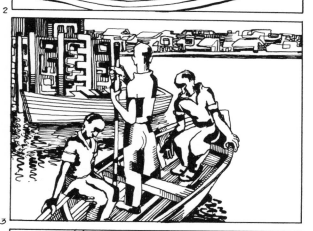

2

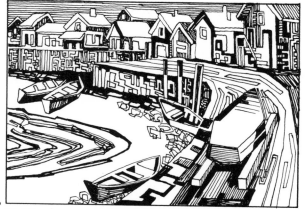

6

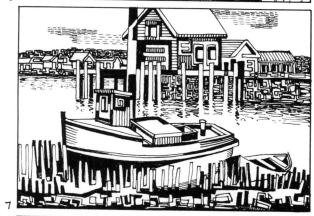

3

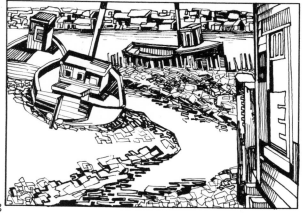

7

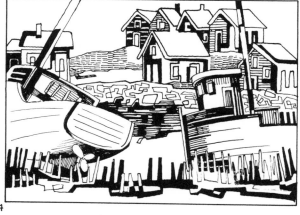

4

8

union of two different motifs—namely, house and boats—by means of curving and straight lines. The curved lines form an almost continuous path for the eye, beginning at the lowest central part of the picture and traveling up to the right, then left and around.

In the variations in Figure 8 on Plate 36, the composition on the right carries out the division between the two motifs quite distinctly, while the composition on the left features the flow of line, forming a continuous path.

PLATE 36 Second developments from selective compositions.

The compositions in this plate are derived from the eight pictures of Plate 35. Each variation is a simplified statement which retains most of the essential characteristics of the original. Compare the treatments shown in this plate with those of Plate 41.

Each composition is considerably more abstract than the original. The process of simplification, in general, leads to abstraction: the more one simplifies, the more abstract one becomes. This is especially true when one begins with something from nature, whether it be landscape, human figures, or still life. Starting with forms of the greatest possible complexity—namely, natural forms—the direction must be toward simplification. The process is reversed when starting with the simplest geometric figures, such as lines, open and closed. The direction in this case is toward complexity.

The merit or virtue in a composition is not necessarily related to its relative simplicity or complexity. A composition may be very simple and very bad, just as it may be very complex and also very bad. The form that pictorial expression takes is not a guarantee of its worth.

From the painter's point of view, it is to his best interest to experiment with form, movement, color, and derivation of motif material so that he may learn about the essential pictorial nature of the material at his command and thus widen his power of self-expression.

NOTE: Compare Plates 29, 36, and 41.

The Art of Pictorial Composition

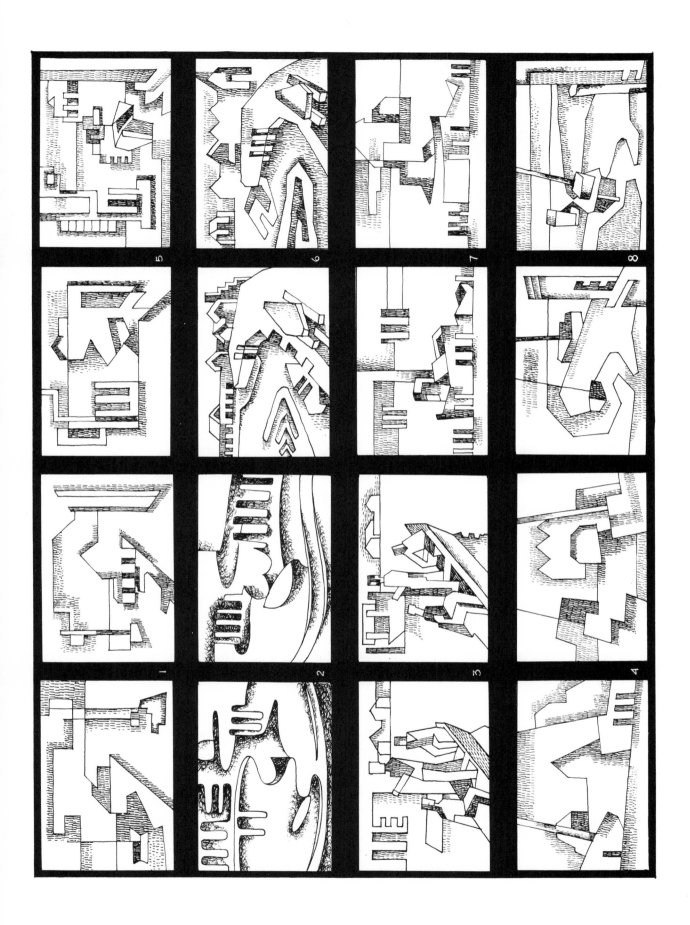

PLATE 37 Various aspects of outdoor subjects.

The four compositions in this plate represent a group of farm buildings, sketched from different viewpoints. It is always advisable to make drawings from as many different viewpoints as possible. The changing combinations of shapes, contours, and light and dark values give the sketcher invaluable material.

I don't suppose that anyone can do too much drawing and painting, but it must be remembered that mere quantity is not an adequate substitute for study and reflection. What count most in the long run are the knowledge gained, the feeling of release and freedom, and the assurance that memory can be relied upon to produce the required details.

Have you ever seen the very attractive advertisements offering color boxes with 24, 36, and sometimes as many as 48 different pigments? Very few experienced painters use more than eight or twelve colors in their palette. Mere quantity will not help in learning how to control color. Quite the same situation prevails in studying composition. Don't draw aimlessly.

In each of the four compositions of this plate, the silo is the area of chief interest. I suppose that this odd-shaped building caught my eye and held my attention. In each version the silo is located more or less in the central area of the space and is flanked by almost equally balanced building details. While the general schematic arrangement is almost the same in each picture, there is considerable variation in the way in which the various shapes are arranged. Study and compare the four designs for similarities and differences.

Figure 4 of Plate 37 is the basis for the different treatments illustrated in Figures A, B, C, and D. The essential shapes have been retained. The principal changes were in black and white treatment and in simplification of the building forms.

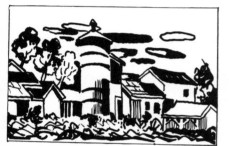

FIG A

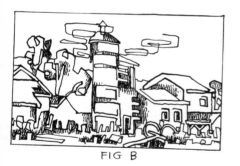

FIG B

FIG C

FIG D

The Art of Pictorial Composition

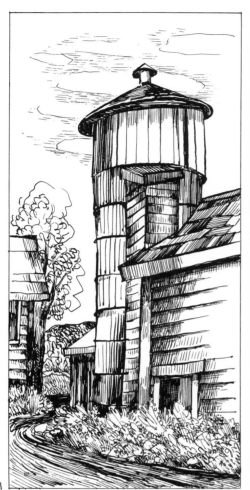

1

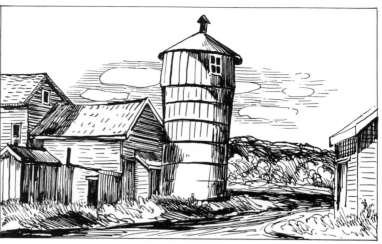

2

3

4

PLATE 38 Selectivity in composition from nature; source material

This plate offers source material in a variety of subjects. Plates 30 and 32 have several additional compositions to be used as source material.

I have tried to stress the importance of observation, memory, and drawing. The three are united every time we commit something to paper, and the more of it we do, the greater the reservoir of knowledge and experience we have from which to draw.

As far as you are able, be original. The source material offered by me should not be used unless you feel that working from it will be just the stimulus you need to get started.

Draw, draw, draw.

Compose, compose, compose.

Paint, paint, paint.

Try large, small, regular, and irregular shapes. Try them all as long as you keep working.

PLATE 39 Street scenes – realism.

The source material for these six street scenes were drawings made out-of-doors.

Figure 1. Gloucester.

Figure 2. Kingston, New York.

Figures 3 and 4. Brooklyn, New York.

Figures 5 and 6. Manhattan.

On Plates 40 and 41 I have created a series of four variations of each of these six street scenes. I have tried to retain in each variation something of the mood and general character of the original. At times a quite simple composition has been evolved. The degree of complexity varies considerably. Nowhere in any of the 24 variations have I attempted a simplification or abstraction that would go beyond a recognizable similarity between the original and its off-shoot. This restriction was deliberate. Elsewhere in a number of the plates I have expressed in more abstract terms my reaction to the source material.

The final composition depends not only upon the basic material, whether real or imagined, but upon the mood of the artist, upon his conditioned existence up to the moment when he begins, and, indeed, upon every possible influence that may have affected him in even the slightest degree. If we regard the source material as a constant, it is the painter who is always in a state of change. Is it any wonder that he will react differently to the same stimulus at different times? Is it any wonder that it is possible to create almost countless designs from the material which we gather or experience and which in one way or another becomes part of us?

I have written elsewhere that I keep every sketch, drawing, and painting, good, bad, or indifferent. I do this because I cannot tell in advance when I shall wish to convert these experiences into pictorial form. This poses a storage problem, but the more important problem is that of using our experiences to the fullest advantage.

The Art of Pictorial Composition

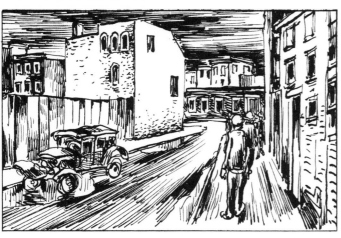

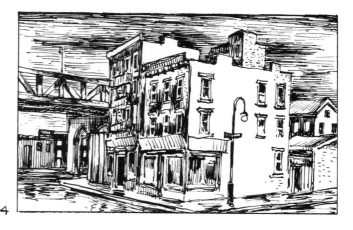

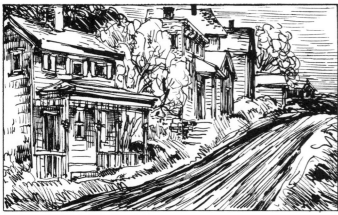

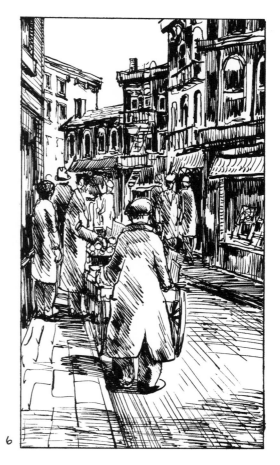

PLATE 40 Compositions derived from Plate 39.

Figure 1—Gloucester street scene. In Variation A the dominant lines are vertical, resulting in long, upright, almost rectangular areas. The diagonal lines and areas create enough interest to add variety, but do not detract from the verticality.

In Variation B the area of chief interest is more concentrated than in Variation A. The diagonal lines and areas play a more important role. The essential vertical character is maintained.

In Variation C activity has been greatly increased. There is definite opposition to the vertical lines and areas, resulting in greater tension. The chief interest is located on the right side, as in Variation B, but an important secondary interest occupies the middle part of the composition.

In Variation D we have the greatest excitement. While the chief interest is still located on the right side, there are two separate subordinate themes or rhythms which are in tension with it. One is the diagonal grouping in the upper part of the design; the other is the vertical grouping in the right center of the picture area. There is also a greater concentration of light and dark contrast leading into the picture.

Figure 2 *—Street in Kingston, N. Y. In the original pen-and-ink sketch on Plate 39, perspective plays an important role, due to the convergence of many lines toward a point midway between the top and bottom of the picture and slightly beyond the picture area to the right. In each of the four variations, perspective plays a lesser role, being almost of no importance in Variation D.

Variation A. The influence of lines converging to a focal point is counteracted by emphasis on the tree and by a set of rhythms to the left and right of the tree. This combination may be regarded as the area of chief interest.

Variation B. Tension is greater in this variation than in Variation A. The lines of the houses are horizontal and create a rhythm that is in tension with the converging road lines. The area in the lower right corner is in opposition to the buildings. The areas in the lower part of the composition, while they lead toward the vanishing point

* See plates on perspective.

FIG-1

VAR-A VAR-B VAR-C VAR-D

VAR-A VAR-B

FIG-2

VAR-C VAR-D

VAR-A VAR-B

FIG-3

VAR-C VAR-D

on the right, also carry the eye to the houses on the left. The left side of the picture is the area of chief interest.

Variation C. In feeling, so far as light and dark values are concerned, Variations B and C are closely related. The converging road lines play a comparatively minor part. The general tension arises from the pull between the area of chief interest of the large house and tree, almost centrally placed, and the tree and hill on extreme right. The horizontal lines of the houses, as in Variation B, oppose the movement of the converging lines in the lower right side of the road.

Variation D. The greatest feeling of opposition, which implies movement, is evoked in this variation. The horizontal, vertical, and diagonal rhythms are in tension. In this composition the chief emphasis is on the right side, off center. The houses on the left, the sky, and the foreground are in balance, giving greater emphasis to the area of chief interest. Unlike Variations A, B, and C, Variation D is composed of two principal parts, each part having its own character, but united by the same treatment.

Figure 3—Street in Brooklyn, New York. In this street scene the point of convergence of many of the lines falls within the picture area and is an important focal point.

In Variations A, B, and C the focal point is very important, while in Variation D the role of the focal point has been greatly subordinated.

Variation A. There are three large divisions in this composition. The most important is the one on the right, containing the focal area. The lesser divisions are: the one on the left, containing the automobile, and the one stretching across the top, made up chiefly of horizontal lines. Notice the balance created by the similar treatment given to the detail in each large division.

Variation B. There are two main divisions united by the horizontal lines and areas of the background. Vertical lines add a rhythm that is in opposition to the horizontal lines. Chief interest is in the figures on the right side, emphasized by the important role played by the convergent lines.

Variation C. The vertical lines and areas are very important, much more so than in any of the other three compositions. Again we have two major divisions, but, compared with Variation B, the tension is greater in this variation. This is due to the fact that the area on the left, containing the car and short verticals, is very emphatic and tends to lead the eye from the focal area, containing

the point of convergence. Notice also that the horizontals of the sky are repeated in the building and car on the left. This combination of horizontals is in opposition to the uninterrupted verticals on the right side.

Variation D. The division between the two dominant areas is more clearly marked in this variation than in Variations B and C. The two parts are united by the very important connecting area of the foreground and the background building and sky lines. Converging lines are of relatively minor importance. The chief interest is maintained on the right side, as in the other variations, but the distinction between the two major areas is not nearly as clearly established.

PLATE 41 Compositions derived from Plate 39.

Figure 4—Brooklyn street scene. The original sketch in Plate 39 is in two-point perspective, with the vanishing points falling outside of the picture area.*

In Variation A chief interest is in the right side. The zigzag lines in the background give importance to the left side and show a kind of rhythm that is barely suggested on the extreme right. The opposition of thematic material helps create tension. The two parts are muted by the uniform tone of the foreground, the accentuated sloping street lines, and the clouds in the sky. Each of the major divisions of the picture has a distinctly different character, but the general effect is that of a united group.

In Variation B the chief interest is centrally located. The left and right sides, while differing from each other, have some elements in common and are of equal importance. The pull generated by the converging lines is equally balanced. The stark contrasts of black and white make Variation A seem muted by comparison. In both Variations A and B the general arrangement of spaces and of directional lines does not vary too much from the original sketch.

In Variation C considerable change from the original drawing has been made by bringing part of the background into the area of chief interest and making it the most important part of the design. The composition is divided into two unequal parts by the vertical line right of center. Despite the difference in area, balance is achieved by a greater concentration of contrasting areas in the smaller right side. Emphasis to the right side is increased by the pull to the right of the sloping converging lines.

In Variation D the motifs in the background have been entirely eliminated. The design is compact, with the greatest concentration of interest in the right side. Notice that the sky treatment, unlike Variations A, B, and C, is almost negligible. Diagonal lines and areas are in the central part of the picture, resulting in a pattern change different from Variations A, B, and C.

* See Part III on perspective.

VAR-A

VAR B

FIG-4

VAR-C

VAR-D

VAR-A

VAR-B

FIG-5

VAR-C

VAR-D

VAR A

VAR-B

VAR C

VAR-D

FIG-6

Pictorial Composition

117

Figure 5—New York street scene. The original sketch is a close-up composition, essentially geometric in character. The four variations in Figure 5 carry out the same feeling. Incidentally, the original is in one-point perspective.*

Variation A. Concentration is on the right side. The principal lines are horizontal and vertical. In fact, the chief departure from the original sketch is in the slight elimination of windows and a greater emphasis on accentuation of lights and darks. The slight variance represents a normal process in the creation of a series of variations. As variations are conceived, they depart more and more from the original. The four compositions in this group show the gradual departure.

Variation B. Concentration is centrally located. A little more attention is given to diagonal lines. The role of the background has been reduced.

Variation C. The diagonal areas are of chief importance. The horizontal and vertical lines of the background offer interesting contrast, but their role is secondary. The departure from the original is quite apparent.

Variation D. Tensions play a more important part in this composition than in Variations A, B, and C. The vertical lines are in opposition to the diagonals and horizontals. Effective use of tonal contrasts adds to the tension. The striking pull of the television aerials on the left is offset by the three parallel curved areas of the lower center.

Figure 6—New York street scene. The perspective uses a focal area located well within the picture plane and creates a concentration of interest. Each of the four variations shows the same general concentration.

Variation A. Convergence of street and building lines brings the eye to the area of chief interest. The contours are rounded. In Variation D all of the contours are sharp-angled. Each in turn creates a homogeneous grouping, different in effect because of the essential difference between a free-flowing line and intersecting straight lines.

Variations B and C, in contrast to Variations A and D, use a combination of straight and curved lines.

Variations B, C, and D. Note:
1. Changes in position of light and dark concentration.
2. Relative importance of background and foreground.
3. Degree of departure from original sketch.

* See Part III on perspective.

The Art of Pictorial Composition

III. INTRODUCTION TO PERSPECTIVE

.

PERSPECTIVE

Consider Figure 1.

We see any object by the light rays reflected from it or by direct light if object is self-luminous. From any point on an object a light ray travels in a straight line to the eye. Each of these rays pierces or intersects the picture plane at a point. The pierce point is called the perspective of the point on the object. We may conclude from this that the perspective of any object, real or imagined, is the sum of all the pierce points of all the light rays that travel from the object to the eye.

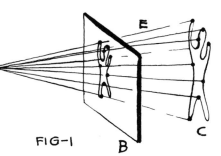

If the picture plane lies between the eye and the object (as in Figure 1), the perspective is smaller than the actual object.

If the object lies between the eye and the picture plane, the perspective is larger than the actual object.

If the eye lies between the object and the picture plane, the perspective may be any size but in each case the picture will be upside down.

When the relationships between the eye, the object, and the picture plane are fixed, there can be one and only one perspective. If there is the slightest change in the relationship, there is a corresponding change in the perspective. A change in relationship refers not only to a change in distance and position but also to a change in elevation and a lateral change in position.

Most painting in the Western world employed in the past, whether consciously or otherwise, a single point of view: that is, all the parts of the picture were arranged so that they could be included within a fixed visual angle. In recent years, beginning with some of the French painters of the late nineteenth century, a multistation point of view has been used from time to time: that is, within the frame of a single picture there is more than one relationship of eye, picture plane, and object. Since any change in the position of the eye, the picture plane, or the object involves motion, the total effect of the multivisual painting is a heightening of its dynamic quality.

Each shift in position produces a new picture. When several such pictures are combined within a single area, the resulting arrangement is a simultaneous expression of different points of view.

This means that we can show the outside and inside of an opaque object; we can show all sides of an object, its top and underside; we can show it right side up and upside down. We can give more information, within a single area, concerning the physical aspects of an object, at the same time introducing a quality of design that cannot be achieved in any other way.

If we imagine an object to be transparent, we can see the outside and the inside simultaneously. However, the resultant composition, because it uses only one point of view, does not have the sense of movement that is imparted by multiple changes in the point of view.

In a multiview composition the problem of what to omit from each change in position is a critical one. The final decision depends on the basic idea that is to be expressed and the amount of simplicity or complexity that will be best suited to the basic idea.

Perspective is a technical subject. Some of it is comparatively easy to grasp because our sight can confirm the truth of some of the principles. For instance, consider this principle: Any system of horizontal lines, not parallel to the picture plane, will vanish in a point on the horizon line, and each system will have its own vanishing point (Figure 2). (A system is a group of two or more parallel lines.) Vision supplies the proof of this principle, for when we stand in the street looking straight ahead, the curb lines, the roof tops, the window sills, all parallel to each other and horizontal, appear to meet in a single point on the eye level or horizon.

FIG - 2

Now consider the following principle: If a system of inclined lines is not parallel to the picture plane, the vanishing point for the system will lie on the vanishing trace in a point not on the horizon line (Figure 3). The visual proof of this statement is not self-evident because the vanishing points do not ordinarily fall within the visual cone of sight.

FIG - 3

The Art of Pictorial Composition

An adequate treatment of the subject of perspective would require altogether too much space and is beyond the scope of this book.

The question always arises as to how much perspective the artist ought to know. The question of how much anatomy, how much drawing, and how much everything else the painter should have is a difficult one to answer.

Can there be such a thing as knowing too much about any subject? I think not. There is, however, such a thing as not knowing enough about a subject. The lack of knowledge is abundantly clear in so much of the work that has always been produced. I am not referring to the works of any particular school of painting, whether naturalistic or abstract.

PLATE 42 One-point perspective.

The role played by perspective is shown in the four Plates 42, 43, 44 and 45.

In Plate 42, consider Figure A. The outstanding feature is the convergence of a great many lines to a single point below center and slightly to the right, within the limits of the picture. Notice that the tops of the heads of the figures are on a horizontal line that contains the point of convergence, or vanishing point. As the figures recede, they become smaller and smaller. This is true of the arches, the windows, and the buildings. If a building in the far distance appears larger than one that is closer to the observer, it means that in reality the more distant house is larger. The general principle is this: Objects of the same size appear smaller as they recede from the beholder. This is true in perspective when the picture plane is placed between the eye and the object.

If we use a rectangular block and place it behind the picture plane and with two faces of the block parallel to the picture plane, we establish a position that results in one-point perspective.

The conditions, as illustrated in the diagram in Figure 1, are as follows:

1. The picture plane lies between point S, the eye, and the object, the rectangular block.
2. Face 1-2-3-4 of the block is parallel to the picture plane.
3. The direction of sight is perpendicular to the picture plane.
4. The block is to the right and below eye-level.

As a result of the four conditions, we get the following:

1. The face 1-2-3-4 and the rear face 5-6-7-8, both parallel to the picture plane, do *not* change shape. Their sizes *do* change, and face 5-6-7-8, being farther from the observer than face 1-2-3-4, appears smaller.
2. The edges 1-5, 2-6, 3-7, and 4-8, being parallel to each other, are perpendicular to the picture plane. This system of lines is parallel to the direction-of-sight line. The five lines meet in a common point, VP, the vanishing point. Note that the VP is the point at which the direction-of-sight line from the eye pierces

The Art of Pictorial Composition

A

B

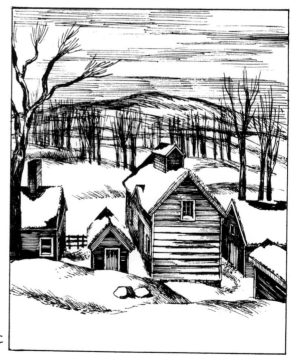

C

the picture plane. The horizon line or eye-level, is a line perpendicular to the direction-of-sight line.

3. Since the block is below eye-level, we can see the top of the block, and, since it is to the right of the direction of sight, we can see the front and left faces.

If the base of the block were above eye-level, we should see the front face, left face, and bottom.

Imagine the eye, direction-of-sight, and picture plane in fixed positions. Let us keep face 1-2-3-4 always parallel to the picture plane but move the box through different positions. The perspective will change with the changes in position. One other illustration will serve to emphasize this.

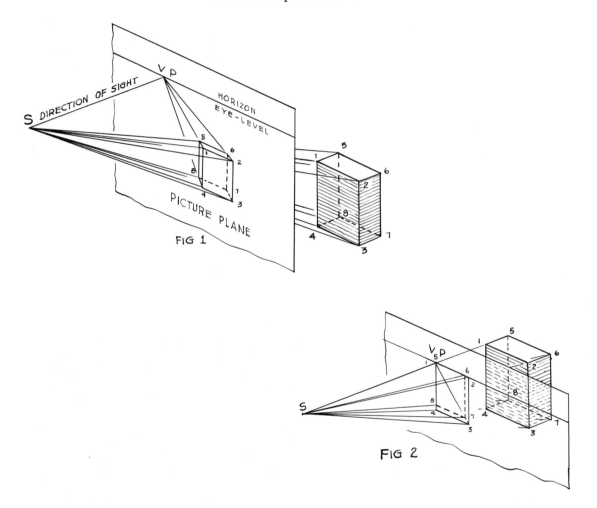

FIG 1

FIG 2

The Art of Pictorial Composition

Observe in Figure 2 that the face 1-5-8-4 shows as a single line. The top 1-5-6-2 also shows as a single line.

(In Figures 1 and 2, edges 1-4, 2-3, 6-7, and 5-8 are vertical. They need not be. As long as the face 1-2-3-4 is parallel to the picture plane, the condition for one-point perspective is satisfied.)

Let us return to Figure A of Plate 42. We have a focal point that is the center of interest. All of the receding lines lead toward it. Anything that we do in the composition to take the eye away from the focal point introduces tension.

In Figures 3 and 4 tensions have been set up by putting in areas of emphasis that are opposed to the focal point. The effect of opposition is heightened by changes in color contrasts and color brilliance.

In Figure B of Plate 42, one-point perspective is used in which the vanishing point lies outside the limits of the picture area. The converging lines direct the eye as in Figure A but, unlike Figure A, the focal point is never reached. As a result, it is easier to introduce an area of chief interest which will not be in opposition to the focal point.

In Figure C of Plate 42, we have an example of one-point perspective in which the vanishing point is located within the limits of the paper. This is not immediately apparent because the converging lines are not extended far enough.

The vanishing point as a focal point in composition is most important in Figure A, less important in Figure B, and least important in Figure C.

PLATE 43 Two-point perspective.

Plate 43 shows three examples of two-point perspective. The conditions for two-point perspective are shown in Figures 1 and 2.

The face 1-2-3-4 of the rectangular block is at an angle to the picture plane. In fact, none of the lateral faces of the block is parallel to the picture plane.

The vertical edges 1-4, 2-3, 6-7, and 5-8 are parallel to the picture plane and remain vertical in the perspective. The edges 1-5, 2-6, 3-7, and 4-8 are horizontal lines, but are not parallel to the direction-of-sight line. Therefore, this system of horizontal edges of the rectangular block has its own vanishing point on the horizon line, or eye level, to the left of the point of sight.

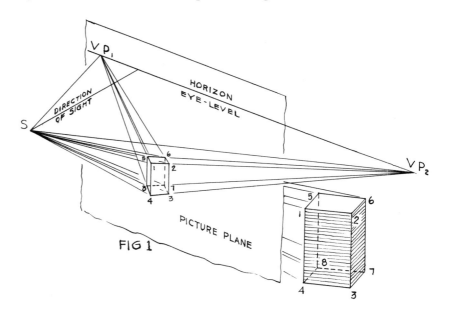

The second system of horizontal lines, 1-2, 5-6, 8-7, and 4-3, has its vanishing point on the eye-level to the right of the point of sight.

Since the whole of the object is below and to the right of the point of sight, we see the top, left side, and front face of the object.

The Art of Pictorial Composition

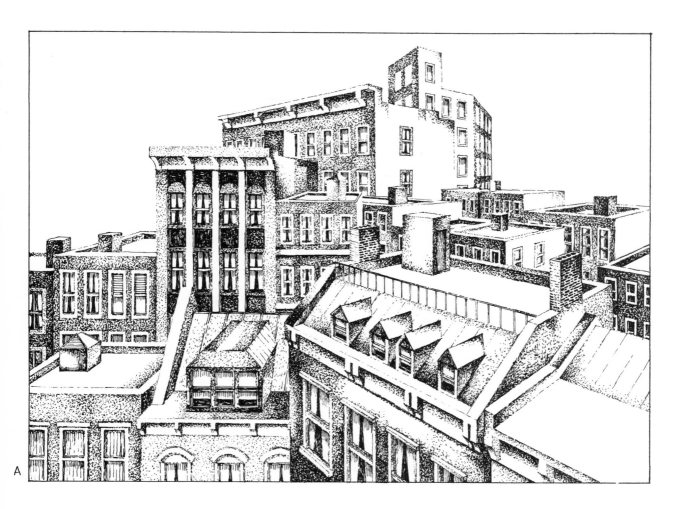

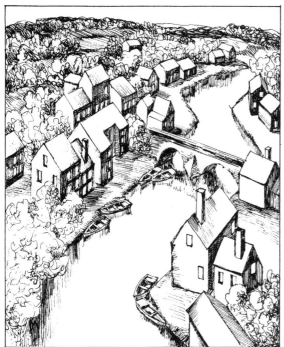

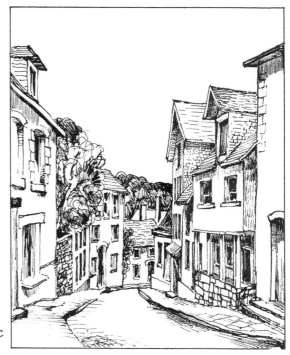

In Figure 2, I have changed the position of the block with respect to the eye, or point of sight, and the picture plane. Note the change in perspective.

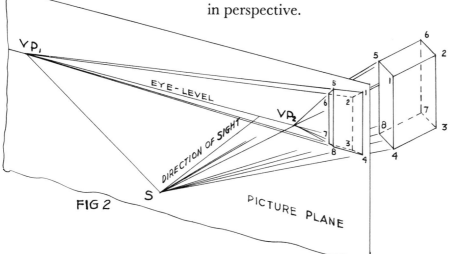

The top of the block is above eye-level, and the base is below eye-level in the new position. The angle of face 1-2-3-4, with respect to the picture plane, has also been changed. The vertical lines remain vertical in perspective, while each system—1-2, 4-3, 8-7, and 5-6, and 5-1, 8-4, 7-3, and 6-2—has its own vanishing point on the horizon line. The vanishing point for the system 5-1, 6-2, 7-3, and 8-4 is to the left of the direction-of-sight line, and the vanishing point for the system 1-2, 4-3, 8-7, and 5-6 is to the right of the direction-of-sight line.

Those systems above the eye-level move downward, each system to its own vanishing point, while the systems below the eye-level move upward, each to its own vanishing point.

Now look at Figure A of Plate 43. The left side of the composition shows a group of buildings that are parallel to the picture plane and are, therefore, in one-point perspective. The remaining buildings are in two-point perspective, showing the faces of the buildings at an angle to the picture plane. This gives rise to a series of vanishing points on the horizon line or eye-level. The roofs of only three buildings are above the eye-level. Note how the lines of the buildings below eye-level converge in an upward direction, while those lines of the buildings above eye level travel downward.

From the point of view of composition, the several vanishing points tend to cancel out each other's importance, particularly if the vanishing points fall outside of the picture area. Emphasis can

The Art of Pictorial Composition

be created by arranging the perspective so that only one vanishing point will lie within the picture area. In this position it will act as an important focal area. By judicious use of value and chroma contrasts, the focal area can be intensified or tension areas can be set up.

In Figure B of Plate 43 a very high eye-level is indicated. The tops of all the buildings are shown and a sense of vastness is imparted. The eye travels to the right because convergence toward the right vanishing point is more sudden and more pronounced. In contrast, the vanishing point to the left seems far removed from the picture area. If we wish to offset the effect of the sudden convergence to the right, we can resort to partial changes in perspective of other parts of the picture or change the value and chroma relationships.

In Figure C of Plate 43 there are a number of vanishing points. The opposite buildings are not parallel to each other and have different vanishing points. The roadway is not horizontal but goes downhill, and the vanishing point for the sides of the road will lie below the eye-level. The focal area is located in the region low in the center of the picture area where the street turns. To offset the importance of this area, we may introduce figures either to the right or left, closer to the observer, or we may change the value and chroma relationships.

PLATE 44 Three-point perspective.

FIG-1

FIG-2

FIG-3

Look at Figure A of Plate 44. The effect is that of looking down from some point high above the roof tops. The direction of sight is *not horizontal* as in one- and two-point perspective but slopes downward.

In Figures B and C of Plate 44, the direction of sight is sloping upward.

Study the following three diagrams. They highlight the essential features of one-, two- and three-point perspective.

Figure 1 shows one-point perspective. The face 1-2-3-4 of the rectangular block is parallel to the picture plane.

Figure 2 shows two-point perspective. The face 1-2-3-4 is at an angle to the picture plane but edges 1-4 and 2-3 are parallel to the picture plane.

Figure 3 shows three-point perspective. The face 1-2-3-4 is at an angle to the picture plane, and edges 1-4 and 2-3 are also at angles to the picture plane.

Figure 1 shows one system of horizontal lines—1-5, 2-6, 3-7, and 4-8—not parallel to the picture plane. Therefore, there is only *one* vanishing point on the eye-level.

Figure 2 shows *two* systems of horizontal lines—1-5, 2-6, 3-7, and 4-8, and 1-2, 5-6, 8-7, and 4-3—not parallel to the picture plane. Therefore, there are *two* vanishing points on the eye-level, one for each system.

Figure 3 shows *three* systems of slanting lines—1-5, 2-6, 3-7, and 4-8; 1-2, 5-6, 8-7, and 4-3; and 1-4, 2-3, 6-7, and 5-8. They are neither horizontal nor parallel to the picture plane. Therefore, there are *three* vanishing points *not* on the eye-level, one for each system.

The Art of Pictorial Composition

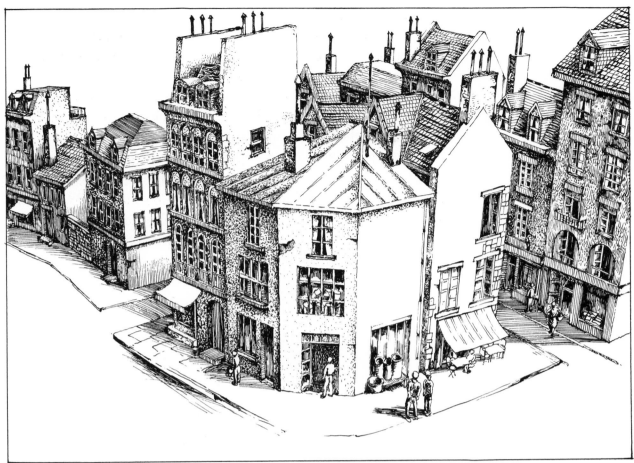

A

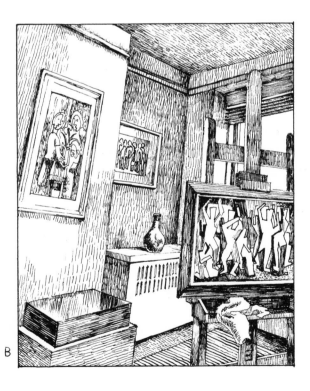

B

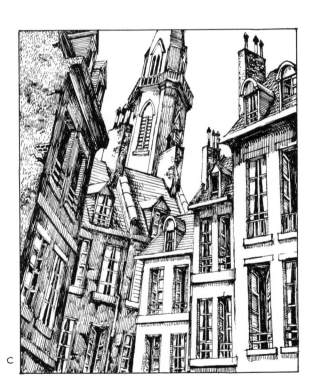

C

Introduction to Perspective 133

Incidentally, it is a simple matter to set up a box in varying positions and make careful drawings, paying close attention to the directions of the edges. Every type of perspective can be thus illustrated.

If we now return to Figure 1, we can get the three-point perspective effect by keeping the rectangular block in the same position but changing the angle of the picture plane.

In Figure 4 the relative angular positions are the same as in Figure 3. Therefore, the perspective will be the same. For practical reasons Figure 4 represents the common method for arriving at three-point perspective. Obviously it is easier to change the direction of sight from the horizontal to an upward or downward slope than it is to change the position of a group of buildings.

FIG-4

NOTE: The picture plane is always perpendicular to the direction-of-sight line.

In terms of composition, three-point perspective introduces three major converging sets of lines. Generally the vanishing points fall outside the picture area, and focal areas are obtained by contrasts of value and color rather than by linear movement.

In Figure A the most pronounced movement is downward, although the contrast with the movements to the right and left is not too pronounced. Of the movements to the right and left, that to the right is less important.

In Figure B movement upward and to the right is important. Movement to the left plays the least important role. Perhaps chief interest is concentrated in movement to the right because of the emphasis placed on the picture that is on the easel.

The Art of Pictorial Composition

BUSINESS REPLY MAIL

FIRST-CLASS MAIL PERMIT NO. 1203 BOULDER, CO

POSTAGE WILL BE PAID BY ADDRESSEE

HEALTH

P.O. BOX 52431
BOULDER, CO 80321-2431

HEALTH
Savings Certificate

Enter my one-year subscription to HEALTH
and bill me later for only $15.97.

NAME: _____

ADDRESS: _____

CITY/STATE/ZIP: _____

The basic one-year subscription rate for HEALTH is $18.00.

4HM13

In Figure C the dominant movement is up to the right. The soaring effect is achieved by concentrating on the series of converging lines that we know to be vertical in the actual scene.

In each of the illustrations on perspective I have deliberately omitted many details and have purposely refrained from the use of striking contrasts of light and dark. I have tried to show how the natural, or realistic, direction-of-sight line can be an important factor in composition.

PLATE 45 Multiple viewpoints in perspective.

Of the six variations in this plate, Variation 2 is the only one in which the interior is drawn from one point of view or a fixed line of sight. In Variation 6 two lines of sight are used. In Variations 1, 3, 4, and 5 three lines of sight are used.

The effect of using more than one point of view in a single composition may sometimes appear strange or bizarre, but it frees the artist from the restrictions imposed by what is sometimes called "true perspective."

The practice of using multiple viewpoints in a single canvas has a time-honored tradition. To cite one example, there is a marvelous self-portrait by Rembrandt in the Frick Museum in New York City. One of the hands is shown in deep shadow. Its position is such that it is farther from the onlooker than the hand that is in full light. Rembrandt drew the hand in shadow much larger than the other hand, even though true perspective would have dictated the reverse. He used two different viewpoints.

The validity of an artist's use of multiple focal points depends not upon precedents established by Rembrandt or anyone else, but upon the degree to which they help him realize a specific idea.

The use of more than one viewpoint makes possible:

1. A heightened sense of movement.
2. A greater feeling of roundness (since more than one aspect of an object can be shown).
3. Additional opportunity to control, by size and position, the relative importance of various parts.

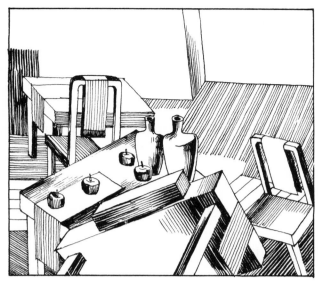

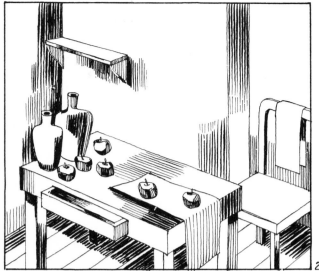

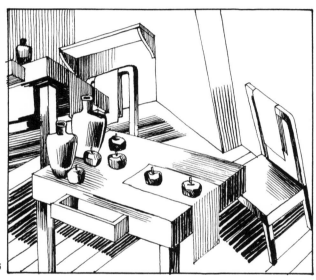

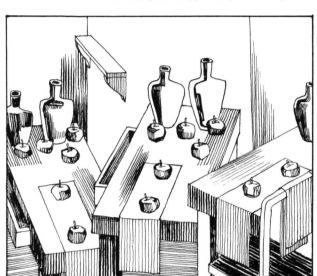

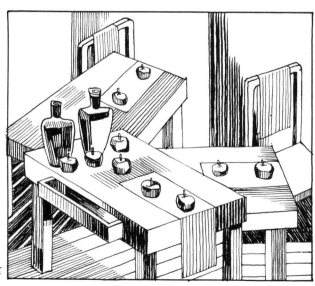

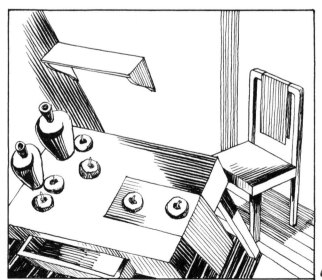

PLATE 46 Control of dynamic effects.

Plates 42, 43, and 44, which deal with perspective, emphasize the value of the vanishing point as a focus of interest. In the same plates it is suggested that one way of counteracting the effect of perspective lines is by introducing new areas of contrast.

In Plate 46 perspective plays an important role in a different way. Perspective implies distance. It also means that when an object, called **A**, is partially hidden by another object, called **B**, object **A** must be in back of object **B**. The sense of recession is expressed not by converging lines or by changes in size, but by our awareness of the fact that two objects cannot occupy the same space at the same time.

Look at Figures A1 and A2. The linear arrangement is the same in each, but the focal areas are different.

In Figures B1, B2, C1, and C2 the focal areas have been shifted as in A1 and A2. The change in emphasis has been accomplished by altering the value relationships.

This device is an important way of introducing tensions in pictorial composition. Figure A1 shows how the eye, which would ordinarily go to the topmost part of the composition, is arrested by the marked emphasis of the plane sheets and the cylinder on the right.

Incidentally, the deliberate change in focal areas by means of value contrast changes has nothing to do with aerial perspective. We have dealt with some phases of linear perspective. In aerial perspective we deal with the natural phenomenon of the graying of color, or loss of chroma, and the gradual diminishing of contrasts in value due to the effect of distance.

If we wish to make an object appear to be in the far distance, we can do it by change in size, by change of value, and by change of chroma.

A-1

A-2

-1

B-2

C-1

C-2

Introduction to Perspective 139

PLATE 47 Control of dynamic effects, using single theme and variants.

In this plate simple geometric shapes have been assembled to form a series of eight compositions. For the most part, the combinations of area shapes remain the same. Changes have been made in:

1. Focal areas.
2. The effect of advancement of some areas over others.
3. Sense of the three-dimensional form of the area shapes.
4. Key values.

The most striking changes in effect and emphasis can be achieved with the proper use of color. Unfortunately this cannot be shown when black and white alone are used.

As I have suggested in other parts of this book, experiments in composition can be performed with very simple means.

The basic shape in Plate 47 is the triangle and curved variants of it:

Try a series of compositions based on the following:

Use each of the four figures as the basic shape. Create shapes related to each basic shape; then assemble each group in different ways to form new space arrangements, keeping in mind:

1. Movement in depth.
2. Lateral movement.
3. Tension.
4. Value key.
5. Variations in three-dimensional feeling of areas.
6. Changes in areas of chief interest or focal areas.
7. Mood.

This is a large order. Do not attempt all of them at once. Feel your way and start with the one that you can handle most readily.

The Art of Pictorial Composition

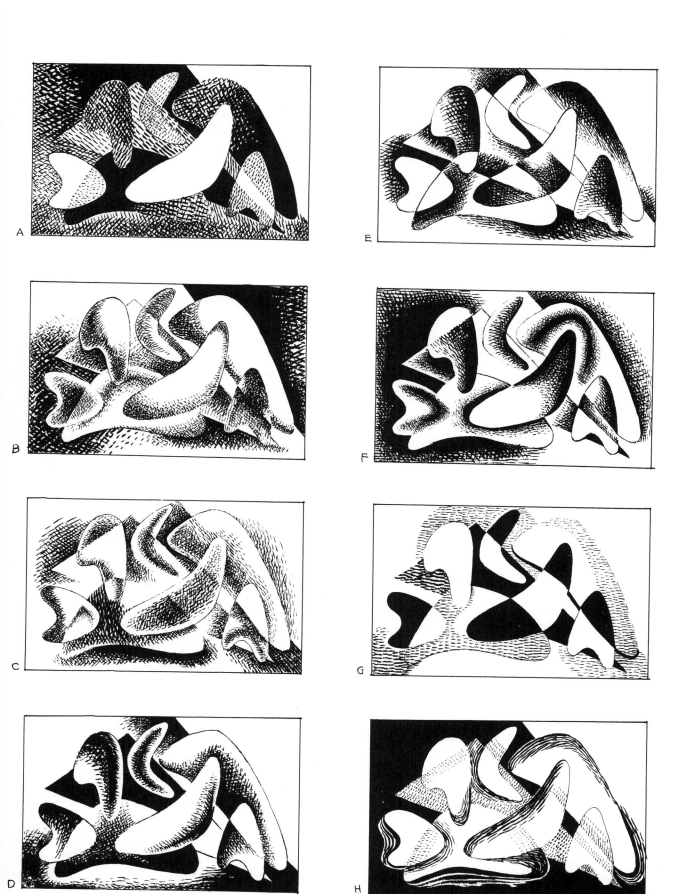

PLATE 48 Shape of picture area and its effect on composition.

In this plate three free-form elements based on the human figure have been combined to form seven compositions. In each example an angular form has been introduced to add contrast to the curved areas and to help unite them.

Figures D and E show how the grouping has been elongated to accommodate the long rectangles. This procedure is immediately suggested by the marked difference between height and width of each rectangle. Under "General Considerations," I have discussed the role that unusual contours play in establishing an initial impulse in a composition. The figures D and E are further illustrations.

Figure C is almost a square, and in it the three figures are grouped closest to each other.

In Figure F a sense of convergence has been added to the quadrilateral. This effect creates a sense of distance which none of the other compositions has. There is an important diagonal which is in tension with the converging lines. From the point of view of dynamic quality, Figure F shows the liveliest feeling.

Do not get the idea that the three basic figures in Figure G have been assembled in a haphazard order, depending upon chance for a good composition.

In each of the seven variations, study carefully not only the relationships between the figures, but the spaces surrounding the figures, the negative as well as the positive areas. All of them are of importance in the creation of satisfactory composition.

As in Plates 46 and 47, simple figures have been used to create relatively simple designs.

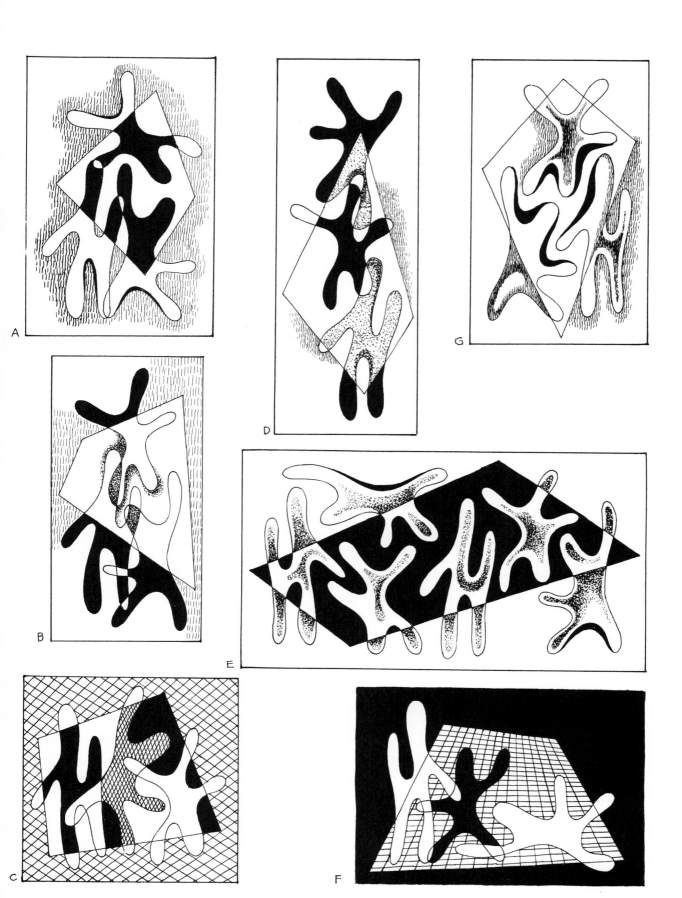

A

B

C

D

E

F

G

PLATE 49 Development of motif in unusual shapes.

In this plate the same motif has been used in both Figures A and B to create two complex compositions. The examples show clearly that it is not the motif, but what you do with it, that counts.

The opening motif of four notes in Beethoven's Fifth Symphony is a striking example of the simplest possible beginning from which can grow one of the most sublime expressions of human creativity. This can happen only when the creator is thoroughly grounded in every phase of technical requirement and, at the same time, has the intellectual and emotional capacity to stir deeply the innermost feelings of his listeners. The same is true in the field of painting.

I am suggesting that in the process of creating a work of art, a great deal more than technique is needed. The emotional and thought content of a composition are subjective things. Anyone but the painter is an outsider, an intruder who can play no important part in those phases of the painter's work that deal with matters other than technique. The student absorbs some of his teacher's ideas and then has the problem of casting them off. He does not always succeed in doing so. Perhaps the best way to put it is to say to the student, "Learn all you can about the mechanics of drawing, painting, and composition, but do your own thinking and express your own ideas—always."

In Plate 49 the motif is:

In Figure A, we have:

1. Concentric ellipses.
2. Converging figures.
3. Rhythm of heads and feet.

FIG 1 FIG 2 FIG 3

The different rhythms add to the complexity of the design and create areas that are interesting and alive, but do not overwhelm the most important aspect of the composition, which is the feeling of convergence. Note how the concentric ellipses, as they become larger, add a sense of movement which is in opposition to the movement of convergence. This represents part of the tension in the picture.

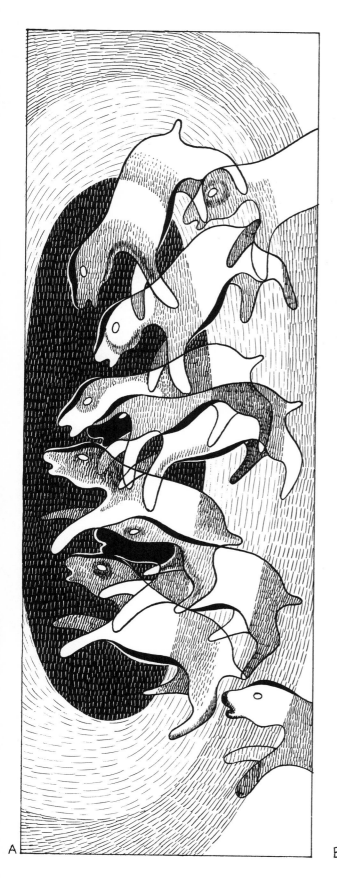

A

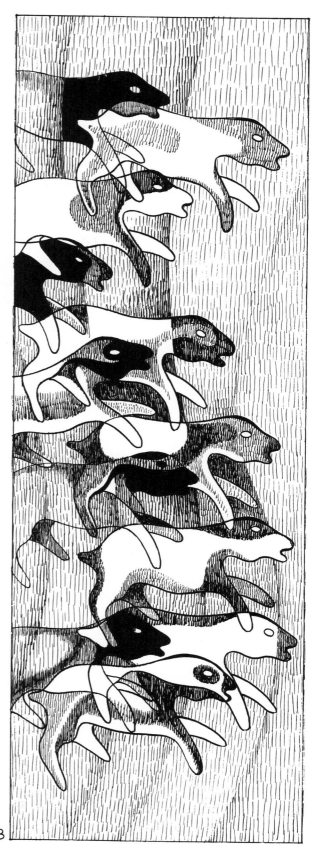

B

In Figure B we have: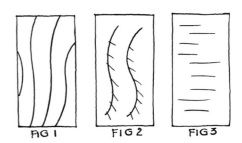

1. Sinuous lines that are not quite parallel.
2. Rhythm of the heads and feet.
3. Rhythm of the bodies.

Each of the three different types of rhythm is composed of almost parallel parts. The horizontal movement of the bodies carries beyond the picture area. The implied movement is continuous, whereas in Figure A, because of the convergence of the bodies, the movements tend to arrest themselves at the point of convergence.

On the opposite page note the series of motifs. Create your own compositions based on these motifs.

The Art of Pictorial Composition

PLATE 50 Development of geometric source material.

This plate is another example of the expansion of very simple source or motif material into pictorial form. The geometric nature of the figures makes it relatively easy to create abstract compositions.

Straight lines crossing and forming open and closed spaces are the devices used. Emphasis has been aided by the addition of parallel lines. The high key, with its marked contrasts of light and dark, has been maintained in each of the twelve compositions.

1. Notice the counterbalance of sloping lines.
2. Pick out the dominant and subdominant areas.
3. What effect would a change in key have on each picture? Study each variation separately. (See Plate 18.)
4. Create a series of compositions, using as basic figures the following:

5. Invent your own motifs and elaborate.
6. Try to react in color. Decide upon a different color for each design and make it the basis for a color treatment. Augment with tints and shades and black and white.

 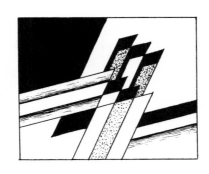 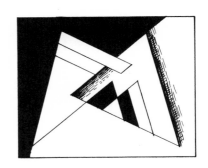

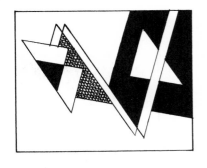 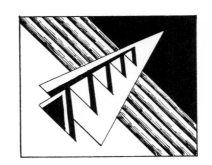

PLATE 51

Plates 50 and 51 are closely related, in so far as simple geometric lines have been used to create the motif material.

In Plate 51 each of the 15 compositions shows a development from a combination of straight and curved lines. This plate is not to be looked at as just one large design, giving the effect of stained glass, but as separate and distinctly different arrangements. If you have any difficulty isolating any one of them for study, simply take a sheet of paper, cut a rectangular hole in it the size of each variation, and place it upon the one you wish to investigate.

1. Contrast the key of this plate with that of Plate 50.
2. Note the use of parallels.
3. Note the radial effect of several compositions; the movement toward a central area or away from it.
4. Study the effect of counterbalance.
5. Using the following motifs, create abstract compositions:

6. Invent your own motifs.
7. As in Plate 50, try to find a different basic color for each composition and elaborate.

The Art of Pictorial Composition

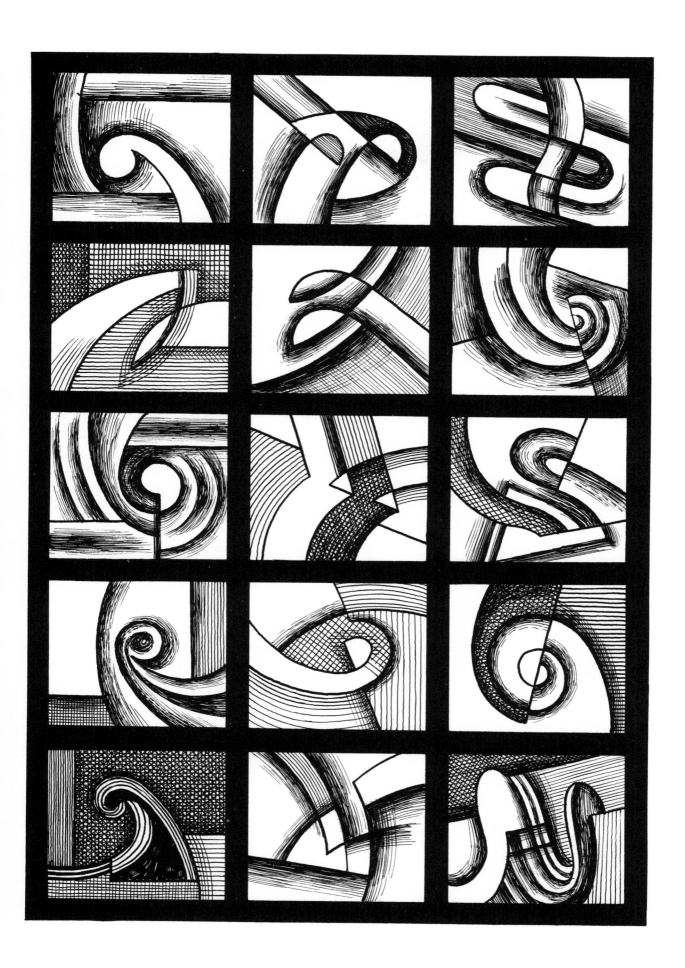

PLATE 52 Seven geometric figures, arranged in varying units.

This is another plate in which simple geometric figures, the triangle and the circle, have been combined to form abstract compositions.

The schematic unit * arrangements fall into three categories:

* A unit is an assemblage of closely united figures.

1. Two groups, in which one unit contains three figures and the second unit contains four figures (Figures A, B, C, F).

2. Two groups, in which each of two units contains three figures, and the units are united by a triangle (Figures D, E).

3. Three groups, in which two units each contain one triangle and one circle, while the third unit contains two circles and one triangle (Figures G, H).

Concentration of interest is enhanced by the use of large areas, which have the same feeling of angularity as the triangles.

The least striking effect of contrast is shown in Figure H, where the variations in light and dark are less marked. The greatest contrast is probably shown in Figure B.

Study the eight compositions of this plate for their groupings of figures, linear movement, and movement in depth.

Suppose that you were planning a composition involving seven human figures instead of seven geometric figures. This would call for a great deal of preliminary sketching of various combinations. Considering the enormous number of possible designs that can be created with seven figures, it is hardly likely that you would get what you wanted without experimentation.

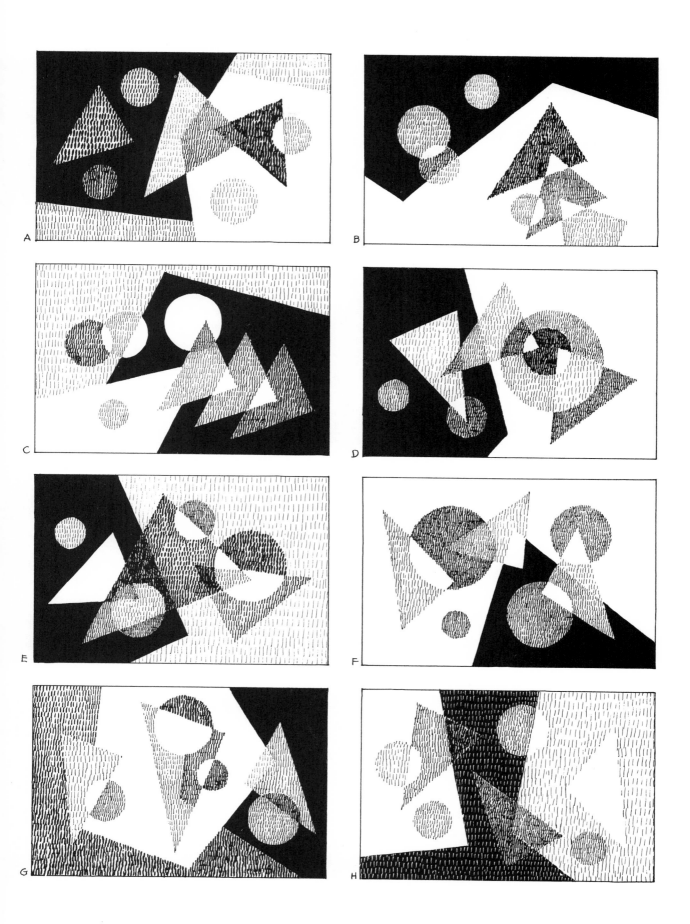

IV. COLOR

COLOR

Color is light.

Color is pigment.

The painter uses pigment exclusively; therefore we shall confine ourselves to a study of the properties of pigment that are indispensable to the art practitioner.

A pigment is a chemical compound. It may be composed of iron and cyanide, as in the case of Prussian blue, or it may be dug from the ground, as in the case of raw sienna, which may be heated and converted into burnt sienna. In any case, whatever the chemical make-up of the pigment may be, the painter is interested in identifying the pigment as a red or a yellow or a green hue.

When we name a pigment "red," we mean, in effect, that all of the light rays of varying wavelengths have been absorbed by the chemical compound except that wavelength in the spectrum which corresponds to red.

Why certain combinations of pigments or chemicals have the property of selective absorption is a mystery that has yet to be solved by physicists. The truth of the matter is that very little is known about that puzzling phenomenon called light, and what is known is not of very great practical use to the painter.

If you have had any experience with color, you undoubtedly know that there is no one single pigment of any hue that may be considered ideal. For instance, there is no one single blue pigment that satisfies our needs completely. If we use ultramarine or cobalt blue in combination with yellow, the resultant green will be somewhat grayed because of the minute quantities of red in the blue pigment. If we combine yellow and Prussian blue, the green will be cold because of a preponderance of green in the Prussian blue. In general we may say that when we use pigment we are dealing in compromises. We have to do our best to overcome the shortcomings inherent in the chemicals that we call pigment. There is no such thing as pure pigment, and therefore there is no such thing as pure color. There is the pure color of the spectrum, but it is of no use to the painter.

I have at no time resorted to accurate measurement of the amounts of pigment used either by weight or volume. I am well aware of the fact that precision is a highly desirable factor in the commercial manufacture of color, but the painter will profit much more by the development of his sense of awareness and sensitivity to color changes if he resorts to what may be called roughly a hit-or-miss method. As he studies the misses and makes what he thinks and feels are the necessary adjustments, he builds a residue of experience that is worth far more than any measuring scale, however sensitive it may be.

Bear in mind that the tubes of paint one buys represent standards set by manufacturers and as such are useful to them and to the painter, who can be reasonably sure of getting substantially the same hue when he asks for a tube of cadmium yellow, regardless of the brand name. Beyond this point the painter is on his own and creates his own color combinations and in the strictest sense of the word has developed his own individual concepts as to what constitutes one type of color as opposed to another.

I know that the temptation to use a great many colors is a strong one, especially since a paintbox full of attractive-looking tubes appears so inviting, but it may prove to be too much of a good thing. Learn how to mix the color you want. Gain control by experimenting with the basic colors. What happens after that will be an interesting speculation.

The Art of Pictorial Composition

COLOR SUGGESTED:

1. Red (approximately four times as much alizarin crimson as cadmium red—extra pale).
2. Blue (approximately two times as much ultramarine as Phthalo blue).
3. Yellow (cadmium yellow).*
4. Orange (approximately two times as much yellow as red).
5. Green (approximately two times as much yellow as blue).
6. Purple (almost equal amounts of red and blue).
7. White (titanium white).**
8. Ivory black.***

When ivory black is added to cadmium yellow (light), the resultant yellow appears greenish. This is due to the blue in the ivory black.

When lamp black is added to cadmium yellow (light), the resultant yellow appears orangy. This is due to the red in the lamp black.

Here are some basic definitions:

Hue This is the common name by which colors are identified, such as "purple," "orange," "burnt sienna."

Tint This is a hue to which white or water has been added. The greater the amount of white or water that is added to a fixed amount of any hue, the lighter the hue becomes and approaches white as a limit. White may be regarded as the *extreme* tint of *any hue.*

Shade This is a hue to which black has been added. The greater amount of black used, keeping the amount of hue fixed, the darker the hue becomes and approaches black as a limit. Black may be regarded as the *extreme* shade of *any hue.*

(Gray is a combination of black and white and varies as the proportion of black to white changes. Any gray from almost white to almost black will produce a shade when added to a hue.)

Value

1. Variations of grays from white to black.
2. The black, white, and gray equivalent of any hue (every color has a value equivalent).

* You might add approximately one-eighth by volume cadmium yellow-medium.
** When using pure aquarelle, white pigment is not used.
*** You might mix equal amounts of lamp black and ivory black. Ivory black is a cold black. Lamp black is a warm black.

Chroma Degree of purity of a color. With the addition of white or black, a color loses its intensity or purity. The color may become more luminous when white is added, but it loses some of its chroma because the addition of white adulterates the color related to the degree of excitement produced in the cones of the eye. The cones are sensitive to color variations. The rods are sensitive to light and dark variations.

Primary color Red, blue, yellow. These are the basic colors from which all others are derived when used as pigment.

Secondary color Any combination of two of the three primaries.

Gray

1. Any mixture of black and white in any proportion.
2. Any color that is a combination of the three primaries, red, blue, and yellow, in any proportion.

A neutral gray is a color in which none of the primary colors is dominant.

There are only six basic colors and their tints which are not grayed colors. The six include the three primaries—red, blue, and yellow—and the three secondaries—orange, purple, and green.

Ideal color Any color that does not have, in even the slightest degree, any adulterant color. For instance, the secondary color green is considered an ideal color if it is so constituted that the mixture of blue and yellow does not result in either a dominant yellow or a dominant blue. To put it another way, we may consider green an ideal color when it is neither a yellow green nor a blue green. If we go back to the definition of secondary color, we can see that there is one ideal green, one ideal orange, and one ideal purple. Aside from the three ideal secondaries, we may have any number of secondary greens, depending entirely upon the proportion of yellow to blue. By the same token, we can have any number of secondary oranges and secondary purples.

White In light, white is the combination of all the colors of the prism. In pigment, white is the ultimate tint of any color and is a chemical combination on one end of the value scale, in which there is an absence of any hue.

Black In light, black is the absence of all prismatic color. In pigment, it may be a combination of the three primaries. The ideal black pigment is the ultimate shade of any color and is situated on the other end of the value scale, in which there is no dominant hue.

Actually the two principal tube blacks (ivory black and lamp black) are not ideal colors because the former has a dominant blue while the latter has a dominant red.

Tertiary color Any combination of three colors that contains the three primaries in any proportion.

Complementary color The combination of any two colors that produces a neutral gray.

PLATE 53 Mixture of color.

Color has three main properties: hue, value, and chroma. Complementary colors, as shown in Figure 2, are:

Blue and Orange
Red and Green
Yellow and Purple
$Blue_1$—Green and Red_1—Orange
$Blue_2$—Green and Red_2—Orange
$Blue_3$—Green and Red_3—Orange
Red_1—Purple and $Yellow_1$—Green
Red_2—Purple and $Yellow_2$—Green
Red_3—Purple and $Yellow_3$—Green
$Yellow_1$—Orange and $Blue_1$—Purple
$Yellow_2$—Orange and $Blue_2$—Purple
$Yellow_3$—Orange and $Blue_3$—Purple

When complementary colors are mixed, they cancel out, and no trace of either is discernible in the mixture.

When complementary colors are placed alongside each other or if small spots of one complementary are painted upon another complementary, then each of the colors gains in intensity or chroma. Each one appears brighter and more vibrant in this combination than it would be combined with any other color.

Note in the lower part of Figure 1 how the shades of each color converge toward the black. The area marked S_1 has the least amount of black, while the area marked S_4 has the greatest amount of black. The upper part of Figure 1 shows the tints of each color converging toward the white. The area marked T_1 has the least amount of white, while the area designated as T_4 has the greatest amount of white. As the tints and values of a color increase—that is, as a color approaches white or black—it loses its chroma.

WHITE

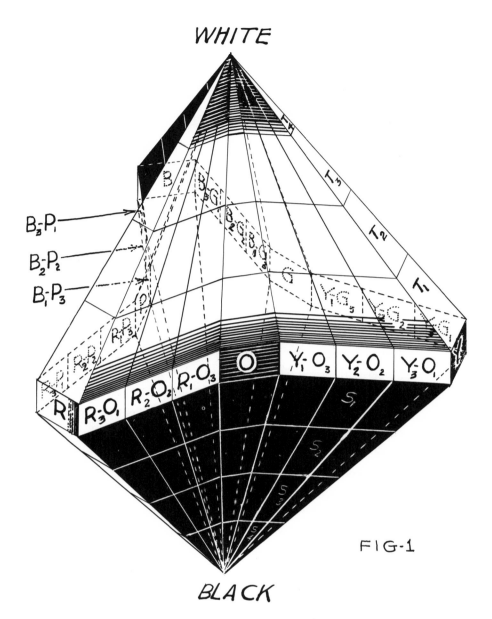

B₃-P₁

B₂-P₂

B₁-P₃

$R_3\text{-}O_1$ $R_2\text{-}O_2$ $R_1\text{-}O_3$ O $Y_1\text{-}O_3$ $Y_2\text{-}O_2$ $Y_3\text{-}O_1$

R

FIG-1

BLACK

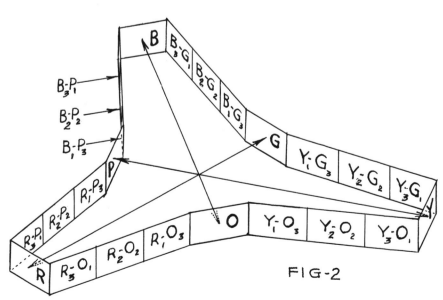

B₃-P₁

B₂-P₂

B₁-P₃

B $B_3\text{-}G_1$ $B_2\text{-}G_2$ $B_1\text{-}G_3$ G $Y_1\text{-}G_3$ $Y_2\text{-}G_2$ $Y_3\text{-}G_1$

P $R_1\text{-}P_3$

$R_3\text{-}P_1$ $R_2\text{-}P_2$

O $Y_1\text{-}O_3$ $Y_2\text{-}O_2$ $Y_3\text{-}O_1$

$R_3\text{-}O_1$ $R_2\text{-}O_2$ $R_1\text{-}O_3$

R

FIG-2

PLATE 54 Values and their effect upon one another.

White, black, and seven tints are used in this plate to illustrate how neighboring values affect each other.

In the left vertical row, all of the small rectangles are the same white. Starting with the topmost and looking at each one, the white seems to get lighter. The lightest or whitest white is on the black background.

If we begin with the bottom one—on the black background—and look upward, the small white rectangles appear grayer, and the grayest is the one on the lightest background.

In the right vertical row, all of the small rectangles are the same black. The blackest black appears on the lightest background.

In the central vertical row, white is the background. The greatest contrast appears in the white and black combination. The lower part of the column seems to advance. This suggests that marked contrasts can produce striking effects.

In the left vertical column the contrasts become more pronounced as they descend to the white on black. The effect of advancement is greatest in the white on black.

The opposite occurs in the right vertical column. The advancement is from the bottom up, with the most advancement showing where the contrast is greatest.

In the horizontal column I have juxtaposed the eight colors, in their proper light and dark sequence. Choose any two adjacent rectangles and gaze steadily at them. You will see that a vertical area next to the darker rectangle will appear lighter than the remainder of the area in the same rectangle. This apparent change in value creates the effect of a rounded surface. In the three vertical columns there is no rounded effect, because of the intervening black in the middle row and the intervening white in the other rows.

Throughout this book there are many examples of the marked effect that neighboring values have upon each other in terms of composition.

I urge the reader to make color charts, black and white charts, and charts having combinations of color and black and white. Independent studies, such as those proposed, add a great deal of experience and control to the difficult problems of color and its effective usage.

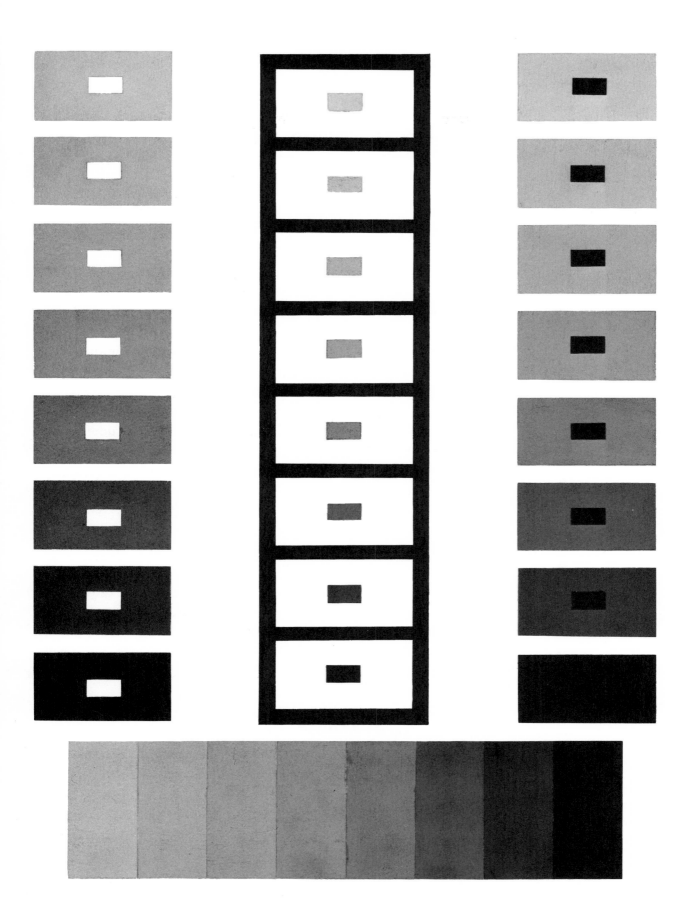

PLATES 55-60 Figure compositions (self-expression).

The final six plates show eleven of my drawings in various pen and brush techniques.

Plates 55, 56, and 57 were on-the-spot drawings, made of people who were not aware that I was sketching them. They were done without any preliminary pencil outline.

In the lower composition in Plate 55, wash was added to the ink outline. In the upper composition in Plate 56, dry-brush lines, giving a wash effect, were added to accentuate the light and dark values. The drawing represents a group engaged in aleatory sport. I was on a sketching and painting trip to some of the mining areas near Morgantown, West Virginia, and made many notes in line and color of the way in which the miners lived, worked, and played.

The two lower figure compositions in Plate 56 were drawn in Kingston, New York, at horse auctions. I made many studies of animals and humans, showing the greatest variety of action in groups and in single figures. Much of this material formed the basis for later development into casein watercolor and oil painting.

Plate 57, a string quartet practicing, was drawn in Woodstock, New York. My interest in music and musicians has resulted in hundreds of studies and finished work in many media.

The lower composition in Plate 58 is a study based on material gathered in Gloucester and Rockport, Massachusetts. It is a composite of several different subjects, united to form a pictorial unit. At one time, some years ago, I painted boats, fishing scenes, the sea, surf, and rocks almost exclusively. Since then, except for specific drawings made for this book, I have not used the sea and boats as subject matter.

The upper composition in Plate 58 stems from a period during and following World War II, when I was concerned with the plight of people all over the world who were uprooted and found themselves in flight. The general theme of flight still interests me very much.

My interest in the human figure in action has been a never-failing

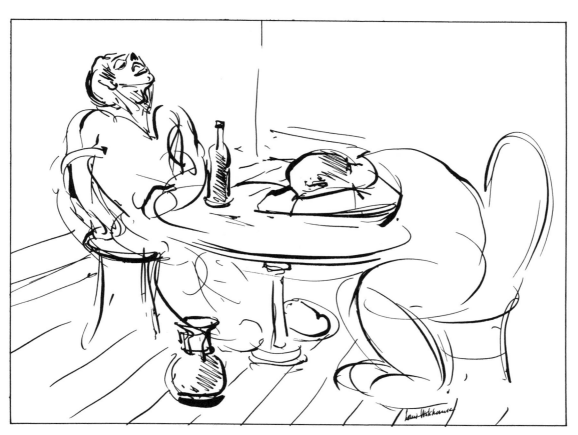

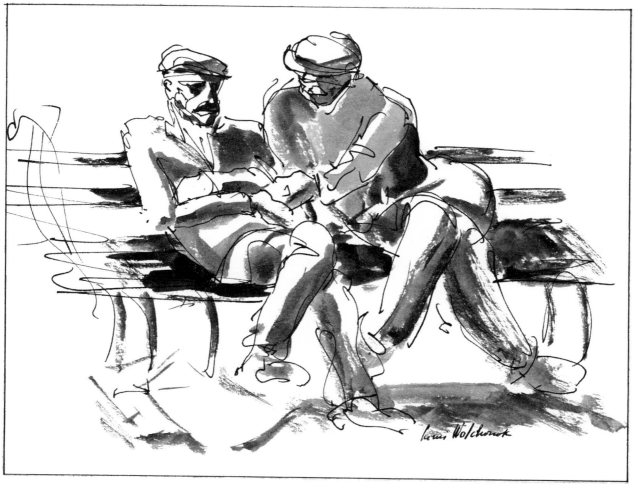

one. It is shown in the dance group, drawn in gray washes, black wet-brush strokes, and much dry-brush work.

In Plate 60 are two compositions that are the direct result of books that impressed me deeply. The upper drawing is called "The Wall" and is one of a series I made after reading and re-reading John Hersey's magnificent book *The Wall*.

The lower drawing was made after reading André Malraux's *Man's Hope*.

I have said nothing of the design aspects of Plates 55 through 60. Obviously the placement of the figures, the distribution of lights and darks, and the moods expressed have not been left to chance. I leave the analyses of their structural content to you.

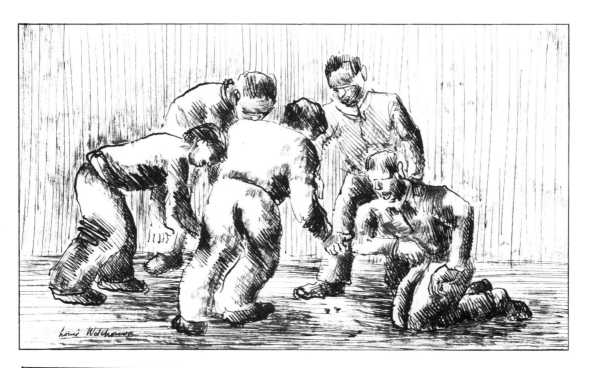

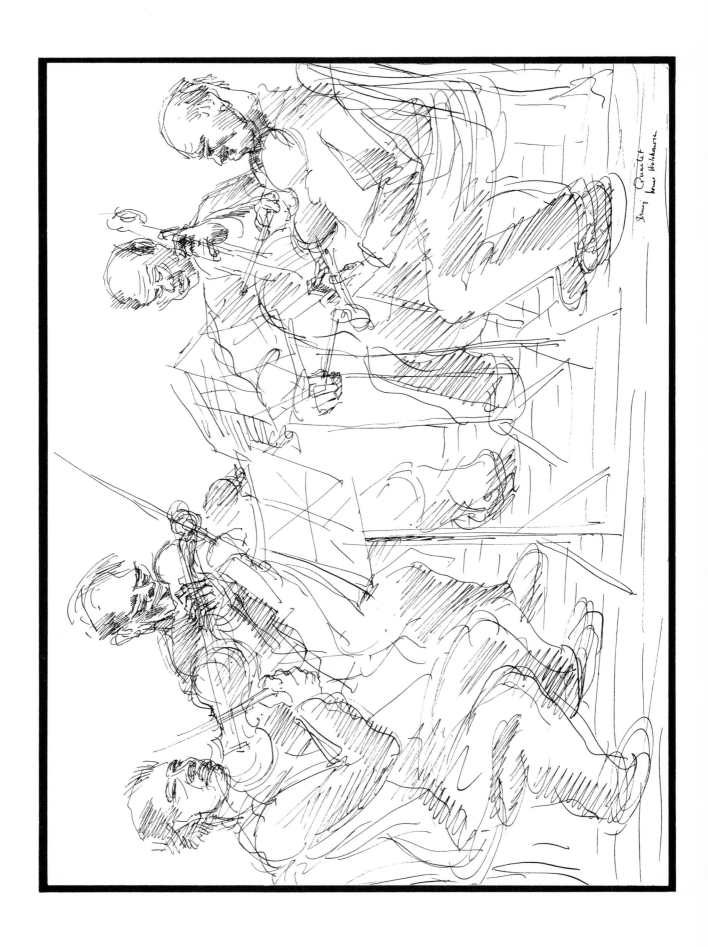

The Art of Pictorial Composition

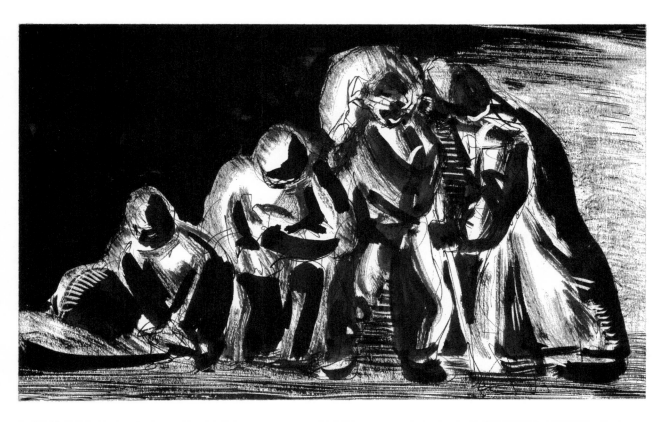

The Art of Pictorial Composition

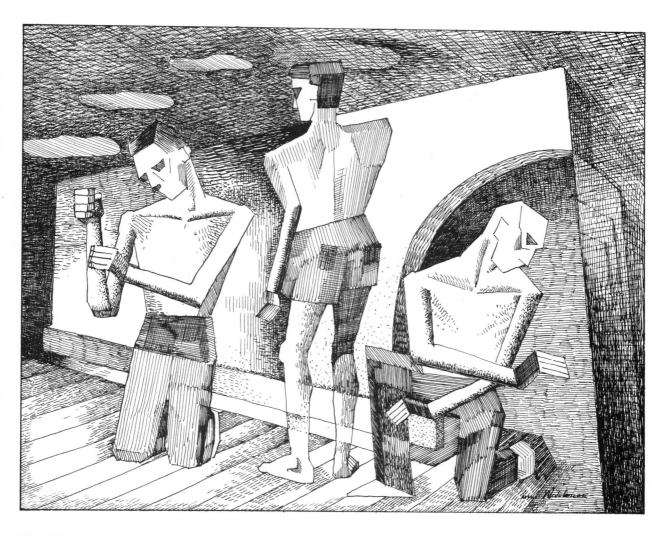

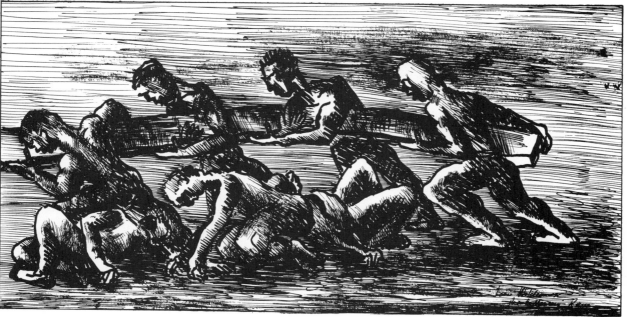

Louis Wolchonok is a professional painter and was a member of the faculty at the College of the City of New York for many years. He has held over twelve one-man shows in painting and etching in New York City and Woodstock, N.Y. Mr. Wolchonok has been a frequent contributor to exhibits of painting and ceramic sculpture all over the United States. His previous books were the popular *Design for Artists and Craftsmen* and *The Art of Three Dimensional Design*.